Beyond the Mosque

Diverse Spaces of Muslim Worship

Rizwan Mawani

I.B.TAURIS

LONDON • NEW YORK • OXFORD • NEW DELHI • SYDNEY

In association with
The Institute of Ismaili Studies
LONDON

I.B. TAURIS
Bloomsbury Publishing Plc
50 Bedford Square, London, WC1B 3DP, UK
1385 Broadway, New York, NY 10018, USA

BLOOMSBURY and I.B. TAURIS and the Diana logo are
trademarks of Bloomsbury Publishing Plc

First published in Great Britain 2019

A catalogue record for this book is available from the
British Library.

A catalog record for this book is available from the Library
of Congress.

ISBN: 978-1-7883-1527-2
eISBN: 978-1-7867-2656-8
ePDF: 978-1-7867-3662-8

Series: World of Islam

Typeset by RefineCatch Limited, Bungay, Suffolk
Printed and bound in Great Britain

To find out more about our authors and books visit
www.bloomsbury.com and sign up for our newsletters.

Published in association with The Institute of Ismaili Studies
Aga Khan Centre, 10 Handyside Street, London N1C 4DN
www.iis.ac.uk

Dedicated to the most resilient
person I know:
my mother

Allah is the Light of the heavens and the earth. The Parable of His Light is as if there were a Niche and within it a Lamp: the Lamp enclosed in Glass: the glass as it were a brilliant star: Lit from a blessed Tree, an Olive, neither of the east nor of the west, whose oil is well-nigh luminous, though fire scarce touched it: Light upon Light! Allah doth guide whom He will to His Light: Allah doth set forth Parables for men: and Allah doth know all things.

(Lit is such a Light) in houses, which Allah hath permitted to be raised to honour; for the celebration, in them, of His name: In them is He glorified in the mornings and in the evenings, (again and again).

The Holy Qur'an 24:35–36

If light is in your heart, you will find your way home.

Jalal al-Din Rumi,
13th-century mystic and poet

Contents

Introduction

Worship has long served communities of the faithful as a means of communication with the Divine. Whether in the form of liturgy, or devotional acts, for many it remains an indispensable facet of day-to-day life. However, in a world increasingly influenced by consumerism and individualism, the concept of worship – with its veneration of an impalpable deity – can often seem far removed from our lived realities. Similarly, while spaces of worship form integral parts of our landscapes, we seldom engage in the significance of their presence. More often than not they have become homogenized into structures synonymous with particular faiths; be it Christianity and the church, Judaism and the synagogue, or Islam and the mosque.

In spite of this, the diversity within faith communities themselves continues to challenge our preconceptions of how and where worship takes place. Just as the Coptic Christian community in Cairo have their own trajectories of piety, influenced in notable ways by their surroundings, so too do their co-religionists in Brazil who make up the world's largest Roman Catholic population. In both cases, their history

and experience of being Egyptian or Brazilian, speaking Arabic or Portuguese, or living in Mediterranean Africa or South America shape their very experience of being human, let alone Christian.

This is similarly reflected in the Hinduism of the West Indies (the leading religion amongst Indo-Caribbeans) and that of Bali, Indonesia. Further accentuating the diversity of each culture is the majoritarian context of one and the minoritarian context of the other. While one case consists of transplanted migrant communities that have found ways for their traditions to consciously speak through an adopted culture, the other exists as a community on an island surrounded by an archipelago of the largest Muslim population in the world. Given this evident diversity within religions, it is only to be expected that Islam – one of today's major world religions, with over 1.5 billion adherents – is no exception.

Muslims form a global community (*umma*) united by a common belief and value system as decreed by God. Essential to this system is the recognition of the Qur'an as God's final message to mankind revealed through His Prophet, Muhammad (ca. 571–632), via the archangel Gabriel. The vast differences in how Islam takes form arise because of the ways in which the Qur'anic text is interpreted by communities and cultures, each with their own trajectories of history, experience and understanding.

Just as there is no single interpretation of Islam, the spaces and rituals that accommodate

Muslim communities across the globe also have no set form. While the mosque has come to predominate over our architectural assumptions and is often considered as *the* place of worship for Muslims, a survey of where ritual takes place – as is done here on my journey through the Muslim world and its sites of piety – demonstrates that there are alternative venues in which Muslims pray. After more than 1,400 years of Muslim history and development, it should come as no surprise that not only do spaces of worship beyond the mosque exist, but they can be found in all corners of the Muslim world. Placing a particular emphasis on ritual practice and space, this book focuses on the variety of expressions of worship that Islam has evoked.

Today, and throughout history, Muslims are invoking established touchstones. Many are cleaving to their own traditions under the threat of homogenization and the attempt to create a 'global Muslim identity'. Others are choosing architectural symbols, such as the dome and minaret, not only in solidarity with other Muslims, but because it is perceived as the 'most Islamic' option, even though these elements may not be indigenous to their own environments. Stories of the first Muslim settlers in Europe and the Americas are often associated with the building of the first mosque or other communal spaces. The ideas of 'first spaces' are also preserved in the memories of migrant communities. Whatever region in the world they may be in, whether it be rural Indonesia or urban Paris, congregations and communities

continue to find ways to interpret what Islam means to them and to express those ideals in the forms of the structures they pray in.

These range from the *imambaras* and *husayniyyas* of Twelver, or Ithna'ashari, Shi'i Muslims (the largest community of Shi'i Muslims, who number in the hundreds of millions), to the *khanaqahs*, *zawiyas* and *tekkes* of more mystically minded Muslims who are usually categorized under the broader umbrella of Sufism. Muslim sites of worship also include the shrine, which not only memorializes sacred figures and relics across the Muslim world, but speaks to the intimate and personal relationships that many Muslims have with religious space. There are countless other spaces that have come, in time, to host the varieties of Muslim devotion and practice, demonstrating how multiple traditions of piety coexist amongst Muslims.

However, while examining spaces of worship serves as a useful avenue for understanding elements of Muslim practice, by no means does it tell us everything about Muslim identities, which cannot be simply reduced to religious convictions or beliefs. While religious beliefs are certainly important for many, we need to be aware that Muslims similarly relate to their regional cultures or their positions in society; for Islam has many voices – and equally as many faces.

Drawing upon first-hand accounts from my own journey to the Muslim world – and primary and secondary scholarship when necessary – this book offers an anthropological window into

Muslim piety in the early 21st century. In doing so, it is hoped that discussions concerning multiplicity in Muslim space and ritual, and Islam more widely, become more nuanced and more inclusive.

We will begin by looking at three very different approaches to the *masjid*, or mosque. From the earliest historical experiences of Muslims before the establishment of formal institutions, when sites and rituals were still in a state of flux in the Arabian Peninsula and elsewhere, we will explore the emergence of ritual and space. Understanding the *masjid* as the pre-eminent, yet not unique, space used by the earliest Muslims, from its modest beginnings as an adjunct to the house of the Prophet Muhammad to its most elaborate manifestations today, will follow. As we broaden the Muslim religious landscape by considering spaces beyond the *masjid*, diverse sites of piety such as the *husayniyya, jamatkhana, khanaqah,* and *zawiya* come into view. By discovering how Muslim communities – Sunni, Shiʻi, mystical or those that identify in other ways – express their piety in different spaces through shared rituals, we can develop a map of the many divergencies, and commonalities, among spaces and ritual practice in the Muslim world. Is there something we can label as representative of 'Islam' from the perspective of space and ritual practice? Or can we consider a multiplicity of Islamic practices that speak to regional cultures, gender, geography and climate?

Chapter 1

Mosques and their Architectures

Before exploring devotional spaces around the Muslim world – the foundation for this book – I had subscribed to the vague notion that the vast majority of *masjid*s, or mosques, follow a set form. This idea was further reinforced by books on Islamic architecture that tend to feature a certain style of classical building. While there are those mosques that have used artistic licence, stretching one feature, amplifying another or symbolically representing a motif in a particular way, these seemed to be simply variations of a general architectural rule: mosques have domes and minarets. These features not only identify the mosque to those seeking one, but provide a means by which Muslims announce themselves to the broader world. It was not until I began to travel, explore and pray within countless *masjid*s around the world, that I realized how much local culture, politics, and interpretations of history influence the shaping of a mosque and its architecture.

Mosques and their Environment

While the primary function of a mosque is to welcome the faithful for religious practice, the mosque can also encompass a space or complex

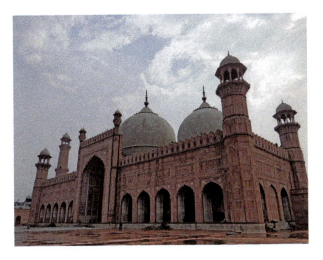

Figure 1. Badshahi Mosque, Lahore, Pakistan
Situated in the capital city of Pakistan's Punjab province, the Badshahi Mosque was built under Mughal rule in 1671. Following the Sikh Empire's capture of Lahore in 1799, the mosque became a military garrison. It continued to function as such during the British Raj until the mid-19th century when the Badshahi Mosque Authority was established to restore the site as a place of worship.

where other structures serve the community in different ways. For example, it is not uncommon to find schools, soup kitchens or even shops within a *masjid*'s complex, encapsulating the larger ethical universe which Islam espouses. While schools provide education, a sentiment echoed in the well-known tradition of the Prophet: 'Seek knowledge, even as far as China', soup kitchens can offer basic necessities for the impoverished. Thus, the mosque is not just an architectural structure, but rather a multidimensional space that can

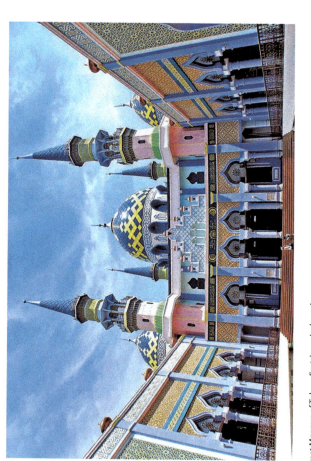

Figure 2. Great Mosque of Tuban, East Java, Indonesia

This grandiose mosque is located in East Java, an Indonesian province known for its volcanic peaks. With six minarets and three large domes, the mosque boasts a spectacular array of eye-catching colours that proclaim its presence in the scenic town of Tuban.

function in various ways – be they religious, political, or social.

Each mosque can be read as an articulation of a community's identity, whether minority or majority, and is a product of the dialogue between the local and the global. In fact, the architectures of Muslim communities overall are the result of a set of factors ranging from technological know-how, geographic locality, landscape and materials, and economics, to interpretations of the faith. It is at this interface that a mosque takes shape.

In every culture that has embraced Islam on a significant scale, one of three aesthetics emerged victorious with reference to religious architecture. In some cases, the architectural sensibilities of the dominant culture – not necessarily Arab – proudly impressed themselves upon the new soil. This is the case with the Uighur Muslims of China and their Central Asian heritage that influences the form of the mosque. In other circumstances, a style which paid homage to the traditions before Islam's arrival triumphed. In this case, the building of an existing dominant religious space might be adopted and slightly altered to reflect the realities of worship, such being the case with the Chinese Hui whose religious architecture is rooted in a Confucian-inspired culture. In the third scenario, a hybrid design developed, incorporating elements of both cultures and worldviews. This is true, for example, of Ottoman Turkey, which incorporated Byzantine and Arabo-Persian elements into its religious architecture.

Taking three examples from my travels, it will become clear just how much the mosque is influenced by the environment and culture in which it is situated, as it is by the conversations from which it emerges. We will see the legacy of a master architect and his patronage by the Ottomans, which paved a new path for Muslim architecture, thousands of miles away from the 'heartland' of Islam; how Hui and Uighur Muslims in China assert their identities through the incorporation of different influences in their mosques; and the ways in which architecture can bring communities together, as in the grand mud structures of Mali's Sub-Saharan plains.

Sinan and Ottoman Mosques

In modern-day Turkey lies the legacy of the master engineer and architect known as Mimar Sinan, 'Sinan the Architect', who lived during the rule of one of the largest empires in world history, the Ottoman Empire (1299–1924). Born of Armenian and Greek ancestry around 1489, the celebrated son of a stonemason belonged to an Orthodox Christian family at the edge of the empire, which, at its height, controlled lands stretching from Central and Eastern Europe to North Africa and parts of the Arabian Peninsula. Sinan converted to Islam upon his conscription to Ottoman service in the capital, Constantinople (Istanbul). At the age of 50, he was appointed royal architect – a position he would keep for the remaining 48 years of his life – where he was notably responsible for defining the scope of

religious architecture in the central Ottoman lands throughout the 16th century. Under his leadership, and with apprentice architects and a government department at his disposal, Sinan executed the construction of more than 350 major structures. He is credited with designing 84 large congregational mosques, known as *jami*'s, and 51 smaller *masjids*, 57 *madrasas*, or theological colleges, seven schools for Qur'an reciters and 17 *imarets,* hospices or public kitchens. He was also the teacher and mentor of many architects who rose to prominence, including Sedefkar Mehmed Agha (d. 1617), the builder of Istanbul's monumental Sultanahmet Camii, also known as the Blue Mosque.

The crown of Sinan's architecture, however, lies not in the city of Istanbul, but in a previous capital of the Ottoman Empire: Edirne. The city is located in modern Turkey's north-west and borders Bulgaria and Greece. Edirne served as the Ottoman capital from 1365 to 1453, before Constantinople was wrested from the Byzantines as the last bastion of the Roman Empire.

The city's religious focal point is the Selimiye Mosque. The grand structure was commissioned by Selim II (d. 1574), the 11th Sultan of the Ottoman dynasty. By this time, Edirne's role as centre of the vast empire whose perimeter stretched from Algiers and Budapest to Baghdad and Mecca, had already been eclipsed by Constantinople, its illustrious neighbour to the south-east. The construction of the Selimiye Mosque in Edirne was an occasion to establish a

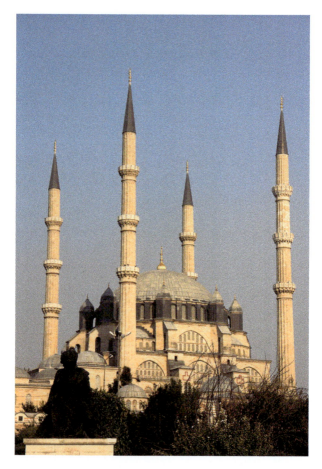

Figure 3. Selimiye Mosque, Edirne, Turkey

The lofty minarets and cascading domes of the Selimiye Mosque tower above the north-western Turkish city of Edirne. Similar in style and form to other imperial Ottoman mosques designed by Sinan, the Selimiye Mosque is often credited as his greatest architectural triumph; a statue of the illustrious architect can be seen from the western side of the mosque, pictured here.

monumental structure in the former capital; Sinan considered it to be his masterpiece.

The mosque with the world's then-tallest minarets framed what was then the world's largest dome – an honour previously bestowed upon the Byzantine-era Hagia Sophia in Istanbul. Breaking away from the traditional single dome of Ottoman and pre-Ottoman religious architecture before him, Sinan pushed the boundaries of gravity and engineering. He replaced the solitary vault with a series of domes and semi-domes: a cascade of convex canopies which looked like they were floating in mid-air. Looking up at the ceiling from within the mosque, an illusion is created which belies its dimensionality, rendering it near flat. On the underside of the domes are intricate patterns of royal blue and eggshell, framing a concert of stained glass windows, which are a ubiquitous feature of Sinan and post-Sinan mosques. Colourful vine patterns in reds and yellows extol the names of Allah and the Prophet Muhammad upon a barely frosted background. Hundreds of these windows surround the mosque. Smaller circles inside larger circles rise higher and higher until their spirals culminate in the highest of cupolas – directly above the mosque's centre. Here, an imaginary line extends downwards and intersects the axis of the *mihrab* (prayer niche), which can be seen from every position in the prayer hall.

Following other Turkish imperial mosques, the Selimiye is the central component of a large *kulliye*, a complex of buildings established with

a *vakif* (*waqf*, in Arabic), or endowment-in-perpetuity. In the case of the Selimiye, the complex contains a *madrasa*, time keeper's room, used by the time keeper or astronomer to calculate accurate prayer times and prepare the annual Islamic calendar, as well as an *arasta*, a row of shops whose rents supported the upkeep and day-to-day running of its other components. The Ottomans advanced the *kulliye*, already common under the Seljuk (1037–1194) and Timurid (1370–1507) dynasties, by linking Islam's emphasis on piety with the ethical imperative of education. The *kulliye* became an important feature of many of the major mosques of the Ottoman caliphate and often included colleges and soup kitchens.

Under Sinan's leadership and vision, the Ottoman Empire championed a distinctive template for the mosque. While in many cultures the mosque already played a multidimensional role, the Ottomans provided an architectural framework, and in doing so enshrined Islam's ethical foundation and the broader functions of the mosque within its architecture and institution.

The Ottoman sultans saw themselves very much as inheritors of the Prophet's legacy, as rulers not only of their own empire, but of the vast Muslim world, with official titles such as 'Commander of the Faithful' or 'Successor of the Prophet and the Lord of the Universe' which were verbally reinforced in the imperial Ottoman mosques. It was common practice to evoke the political sphere of life in religious

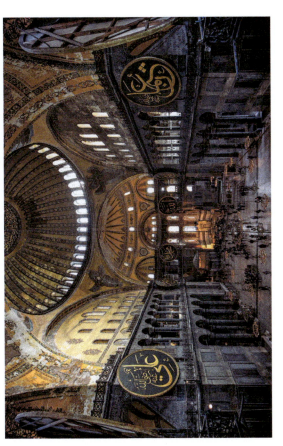

Figure 4. Interior of the Hagia Sophia, Istanbul, Turkey

Formerly a 6th-century Eastern Orthodox cathedral, the Hagia Sophia later became a mosque for nearly 500 years during Ottoman rule, before its re-opening as a museum as it exists today. Thus the interior pictured here reveals an eclectic blend of Islamic and Christian motifs. Large calligraphic roundels bear the names of God (Allah), Muhammad, the Prophet's grandsons, Hasan and Husayn, and the four Rightly Guided Caliphs, namely Abu Bakr, Umar, Uthman and Ali; while the building's apse mosaic, dated to the 9th century, depicts the Virgin and Child, Mary and Jesus.

space, including reading the name of the ruler in the *khutba,* or Friday sermon, as a way of indicating allegiance.

Ottoman mosques also featured large calligraphic roundels, which are still present today, often hanging or fixed inside the mosque and bearing the name of God, Allah, and the names of the Prophet Muhammad and the four Rightly Guided Caliphs who succeeded the Prophet in the governance of the nascent Muslim state, namely, Abu Bakr (r. 632–634), Umar (r. 634–644), Uthman (r. 644–656) and Ali (r. 656–661).

The size of an urban mosque was also often an indication of power and wealth. When the Blue Mosque, arguably Turkey's most recognized and iconic prayer space, was completed by the architect Mehmed Agha in 1616, it became the first mosque other than the Prophet's Mosque in Medina to have six minarets. What may today first seem a relatively minor architectural change, in fact was an assertion of authority as much as it was an ornamental embellishment and feat of engineering, and it was seen by some as a defiant act directly challenging the hegemony of the Arab empires. While Mecca and Medina were considered the sacred heartlands of Islam, the successful Ottoman Empire, which subsumed much of the Arabo-Muslim terrain, was a significant challenge to Arab cultural pride. A religious structure that could be interpreted as rivalling the Prophet's Mosque in Medina had now been built in Istanbul.

As much as Sinan and the Ottoman mosques challenged architectural traditions, they also created an emblem of Ottoman power. Through architectural finesse and engineering expertise, the ruling empire was able to visually announce its dominion to both its subjects and rival powers, proving that the mosque could exist as more than a functional entity. Today we remain witness to humankind's engineering prowess and lofty aspirations in building increasingly tall and lavish structures, which is equally about asserting economic and political power as it is about the defiance of natural laws.

Chinese Mosques

For Muslims residing in lands that were not under Islamic rule, a different sort of challenge was presented – one that was less concerned with the politics of power, but rather with how to establish their own local spaces suited to worship and community needs. For migrants, the cultural identities they brought with them were, at times, far removed from the new environments they settled in.

In the case of China, Muslims first arrived as early as the 7th century through diplomatic and trade relations via southern port cities, and later along the Silk Road. It was not until the establishment of Mongol rule in the 13th century that migration of Muslims from the steppes of Central Asia and Iran took place, consolidating Islam's presence in China and

contributing to the diversity of ethnicities that continue to shape China's population today.

Of China's 56 'nationalities' or ethnic groups, 10 are Muslim. The most prominent of these Muslim groups are the Chinese-speaking Hui, followed by the Turkic-speaking Uighurs – each comprising more than 10 million people. While Hui Muslims have settled in numerous provinces across China, today's Chinese Uighur community remains predominantly concentrated in the north-west, specifically in the Xinjiang Uighur Autonomous Region, where the country's largest population of Muslims reside. When I made my visit in 2006, early on in my research for this book, tensions between the Uighurs and the Chinese-majority Han were already emerging. Although the present fraught political situation in Xinjiang is beyond the scope of this book, it should be noted that the matter is one of grave concern, as widely reported in the media globally.

Urumqi, the capital of the region, and a 30-hour drive from my entry point into China (the Khunjerab Pass), provided an opportune site to explore the mosque and its architectures. The vibrant and cosmopolitan city, whose name is derived from a Mongolian word for 'beautiful pasture', is home to some 3.5 million people of various ethnicities and backgrounds – about a quarter of them are Muslim. Alongside the Uighur and Hui people, who make up Urumqi's largest Muslim populations, other Muslim communities include the Tatars, Dongxiang, Kazakhs, Kyrgyz, Tajiks and Uzbeks.

Moving through the teeming modern town, still diminutive by China's standards, one cannot help but immediately notice the variety of buildings. Brick edifices and pagoda-inspired structures share the city's skyline with rectangular boxes topped with onion domes and glass skyscrapers, where modernist structures give new shape to age-old values. Amongst these are mosques of varying forms, reflecting the diverse Muslim traditions within the region which was once a bustling centre on the Silk Road.

Uighur Mosques

The Uighurs are a Turkic ethnic group that are found today in parts of Kazakhstan, Kyrgyzstan and Turkey. However, the majority of Uighurs reside in the Xinjiang Autonomous Region, where they form the single largest ethnic grouping – most of whom adhere to Islam. While the Uighurs exist as a majoritarian community in this region, as a distinct Turkic-speaking group that was once a nomadic tribe of present-day north-western Mongolia, they remain a minority in the wider context of Chinese society.

Reflecting their ethnic history, most mosques designed by Uighur Muslims follow an architectural model often seen across broader Central Asia, which consists of a large *iwan* (vaulted hall) flanked by two thin minarets. Beyond the *iwan*, an open space gives way to an outdoor garden and an overflow prayer area outside the enclosed main hall. The garden is an integral element of the sacred grounds, not only beautifying and

Figure 5. Prayer Space of the Id Kah Mosque, Kashgar, China
Situated in the heart of the north-western city of Kashgar, the Id Kah Mosque is
one of China's largest Muslim places of worship, accommodating up to 20,000
congregants in its complex. Like other mosques built in predominantly Uighur
areas, the structure incorporates architectural elements that are reminiscent of
Central Asian culture. Pictured here is one of the mosque's outdoor prayer spaces
that features green columns and vibrant tilework that adorns the arched niche
signifying the direction of prayer, otherwise known as the *mihrab*.

perfuming the space around the mosque, but also
modestly mirroring the celestial garden described
in the Qur'an as the place where life originated
and where God and His angels reside.

The main prayer halls share the larger archi-
tectural and decorative motifs that are common to
countries of Central Asia and parts of eastern
Turkey. In these environments, the interiors of
the home and the mosque are nearly identical
and often blurred in their design and layout. They
share, in many cases, the same style of pillars,
carpet motifs and colour schemes, suggesting a

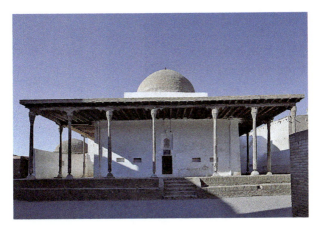

Figure 6. Ak Mosque, Khiva, Uzbekistan

The Ak Mosque, or 'The White Mosque', in Khiva adopts simplistic construction techniques and minimal decorative elements that resemble local domestic architecture. The dome of the main prayer hall sits above a flat roof that forms a veranda around the mosque, supported by carved wooden columns. The mosque seems to have been built in numerous phases; its establishment is often dated to the 17th century, while the mosque's completion is dated to the mid-19th century.

cultural unity, rather than a uniformity, that transcends more recent national divides. These all point to the possibility that the design and organization of religious architecture may have its origins in domestic space – something that can be seen across many cultures of the Muslim world.

As intimated above, in recent years, Uighur Muslims in the region have been subjected to mounting government restrictions on religious freedoms and cultural expressions. The number of worshippers embarking on the Muslim holy pilgrimage to Mecca (*hajj*) is tightly controlled,

while the traditional use of Arabic script among Uighurs has been banned by local authorities. Evidence that mosques have been damaged and even destroyed points to more sinister 'anti-extremism' measures adopted by China. Thus, the Uighurs' relationship to the state and the political climate in Xinjiang remain turbulent. In light of this, the Central Asian sentiments that Uighur mosques inspire become even more signi-ficant, as the mosque transforms into an assertion of heritage and identity in an environment that threatens the very identity of these practising communities.

Hui Mosques

For Hui Muslims, however, religious and cultural identities are less contentious. As Chinese-speakers, Hui Muslims are relatively integrated within Chinese society and can be found in most provinces across China. Despite being descend-ants of Central Asian, Arab and Persian ancestors, intermarriages and cohabitation with the local Chinese population have meant that the Hui population are broadly assimilated.

It is therefore unsurprising that Hui mosques employ indigenous Chinese design elements developed before the arrival of Islam in the 7th century. These include forms most closely associ-ated with Confucian, Daoist and Buddhist temple architecture. In turn, these religious buildings echo traditional forms of Chinese domestic archi-tecture, pointing again to a connective tissue between ritual space and the home.

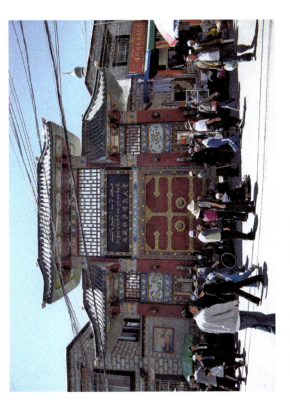

Figure 7. Great Mosque of Lhasa, Tibet Autonomous Region, China

The Great Mosque of Lhasa, situated in the capital of the Tibet Autonomous Region, accommodates a largely Hui Muslim community who originate from inland China. Pictured here is the northern entrance to the mosque that sits within the residential neighbourhood of Wapaling. The entrance adopts typically Tibetan architectural forms and patterns seen in local temples. The official name of the mosque is detailed in Arabic, Tibetan and Chinese above the main gate.

Hui mosques are a series of complexes rather than lone buildings. They are heralded by a solitary gate or wooden gatehouse, horizontally compact but with heavenly aspirations. Upon entering the more elaborate compounds, one is greeted by a series of garden courtyards organized on the axis towards Mecca, the direction of prayer (*qibla*). Beyond this threshold is the prayer hall. Always elevated, the rectangular prayer hall sits on a raised platform, its walls covered with patterns and calligraphic renderings from the Qur'an and *hadith* (traditions of the Prophet), some in illuminated Mandarin characters, others in a stylized form of Arabic bearing the influence of Chinese aesthetics.

Just as the courtyards are demarcated, so too are the spaces within the mosque. Along the main axis, arches and pillars divide the interior and create a visual pattern leading the eye towards the mosque's focal point – the *mihrab*. This niche indicating the direction of Mecca is often decorated with Arabic calligraphy in the prominent local colours of red and gold.

Unlike their Uighur counterparts, Hui mosques, closely aligned with traditional Chinese architecture, reflect the Hui's assimilation into a Confucian-influenced culture that predominates across China. Responding to their environment in different ways, both communities contribute to the variety of mosques that can be found in the Xinjiang Autonomous Region. Cities such as Baghdad, Dushanbe, Dhaka or

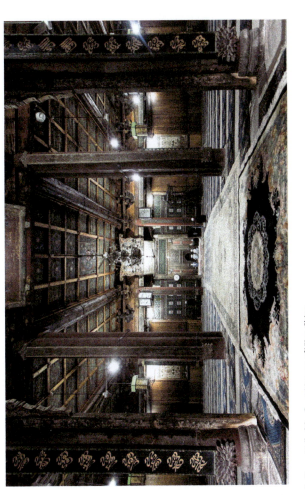

Figure 8. Prayer Hall of the Great Mosque of Xi'an, China

The Great Mosque of Xi'an is an important centre for Hui Muslims in the Shaanxi province. Its large prayer hall, pictured here in 2014, resembles traditional Chinese temple architecture with the extensive use of timber for its wooden brackets and columns. Both Chinese and Arabic calligraphy, as well as floral motifs, can be seen throughout the prayer hall which consists of three adjoined constructions.

Jakarta bring the same point to light: there is no single form for the mosque. Instead, mosques take shape according to the needs and influences of the people who use them. In the case of the Hui and Uighur Muslims, despite their shared heritage, the mosque serves as a marker of the distinct identities that each group has established. Given the sheer number of cultures and communities that make up the Muslim world, it is unsurprising that there is no norm for the mosque, despite what we might be led to believe.

The Mud Mosques of Mali

If we turn to West Africa and Mali's sandscape, where the meandering Niger River encircles its ancient kingdoms, we are struck by how much can be achieved with few resources when people work together with nature's marvels. Rising from the river's serpentine banks, the region's mud mosques extend back in time the further northwest we travel. The most grandiose of these – in fact the largest mud brick building in the world – lies in the middle of a Sub-Saharan flood plain in the antique town of Djenné. Archaeological investigations have revealed evidence of culture dated to the 3rd century, though the market community only rose to prominence very much later, between the 15th and 17th centuries, as traders from Timbuktu passed through selling and exchanging the most precious commodities of the time: salt, slaves and gold.

Despite Islam's long legacy in Sub-Saharan Africa, Djenné's first mosque – or at least its

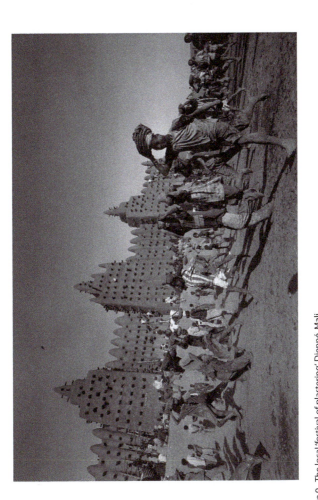

Figure 9. The local 'festival of plastering', Djenné, Mali

Community members take part in the annual replastering of the Great Mosque of Djenné in Mali, photographed in 2005. In the early hours of the morning its walls are coated in plaster by residents of the surrounding neighbourhoods, each competing to plaster their designated part of the building the fastest.

entry in the historical record – did not appear until sometime in the 13th century. In time, older mosques fell and newer ones rose in accordance with different rulers. Built upon the hallowed ground of its predecessors, the current structure known as the Great Mosque was completed in 1907 during the tumultuous period of French colonial rule. While some scholars claim that the French were influential in the mosque's design and construction, others argue that Djenné's guild of masons and local workmen were responsible for its accomplishment. With various threats posed to its preservation, in 1988 it was declared a UNESCO World Heritage site, along with neighbouring archaeological sites.

Approaching the settlement from the north, one cannot help but be awed by its central building, fashioned only from material from its immediate surroundings: mud and sand bound together by water and mortar made of lime and rice husk. When first sighted, the imagination is captured by both the mosque's dignity and its gravity: on its facade, three picturesque turrets punctuated with rods (*toron*) made of palm wood are capped with a pointed spire and adorned with a single ostrich egg, a symbol of purity and fertility. Along its length, three times that of its breadth, protrude thin circular pillars and rectangular towers. Narrow windows in indistinct patterns dot its lower half, welcoming light into its darkened interior.

Large enough to accommodate 3,000 faithful, it is hard to imagine how such a structure survives

in the basin of two rivers whose swelling waters make Djenné an island for six months of the year, accessible only by a causeway. For the remainder of the calendar, the building sits in a sea of sand amidst a vivid desert dreamscape. Despite the mercurial changes in weather, just outside the eastern wall is the thriving Monday market, serving a city and its neighbouring villages of approximately 30,000 people and still drawing crowds to this day.

Other than its size, the Djenné mosque is not a unique or peculiar structure. It belongs to a tradition of mosque-building that spans much of Mali's Inner Niger Delta that also stretches to neighbouring northern Senegal and Mauritania. The roots of this architecture, while labour intensive, are in its reliance on local materials. They are plentiful, largely inexpensive and are suitable to arid environments, not only in West Africa but also in other parts of the world, including South America, the south-western United States, Eastern Europe, Western Asia and Southern Arabia.

The word *adobe*, Arabic in origin, has come to designate an organic building made of water, clay or mud, bound together with manure or a fibrous straw or sticks. Its style is common to some of the oldest buildings in the world and in its Malian iteration it is finished with a plaster known as 'banco', which consists of fermented mud and grain husks. While such materials have proven to be both sustainable and environment-ally friendly, structures of these kinds require

a certain amount of maintenance. In the case of the Great Mosque of Djenné, the surrounding riverbanks are prone to flooding and must be maintained and monitored regularly. However, civil unrest in Mali since 2012 has meant a lack of resources and funding to preserve this site. Conflict, environmental threats and financial stability are just some of the factors that can contribute to the complexity of conservation.

In Mali and the banco architecture of the Inner Niger Delta, however, we see a living and communal tradition associated with this architecture. One consequence of the rainy season is that during the spell of torrential downpours, the mosque's exterior is reminded of its more humble beginnings. The very same water which in fact fastens the sandy crystals together during the dry season, now begins to unravel its magic and separate them. Raindrops wash their way down its outer walls, carving miniature aqueducts down its sides and returning select grains of sand to their more lowly origins upon the earth below.

Thus, this structure also has the power to pragmatically unite the community – not only in its role as a space for congregation, but also in its almost human need to be cared for and tended to. Every year, the townspeople gather together and in an act of solidarity, pat and patch, reform and repair the mosque's now cracked shell back upon its body. The annual spring plastering festival makes the congregational mosque much more than just a place of prayer. It helps to cement

community life in the same way that the natural mortar keeps the bricks of these buildings together.

Weeks before la fête de crépissage, or the 'festival of plastering' – part contest, part festival, part hallowed tradition – large amounts of mud are preserved and barefoot boys churn the sticky substance in shallow tubs. After sunset, music can be heard while men bring forth the mud, and by daybreak the next morning the re-plastering is well under way. It is not just the mosque and the surrounding market area that are boisterous and alive, but the entire city. After much jubilant effort, the mosque's exterior is revived, like a tree which adds a coating of bark with every passing season.

In major centres like Djenné, the mosque and the market are inextricably linked, both by place – their location in the central square – and as a core part of daily life. However, this way of life, with its relationship to community and architecture is under increasing threat. As young men move out of the town, know-how and interest in preserving and constructing banco masonry languishes. Master masons, who have preserved this technique from one generation to another in their hearts and hands, now have fewer interested ears upon which to bequeath these secrets.

The Origins of the *Masjid*

Despite the variety in mosque architectures we have seen thus far, for many there is still a certain image of the mosque that is entrenched in our minds. The image of the dome and minaret

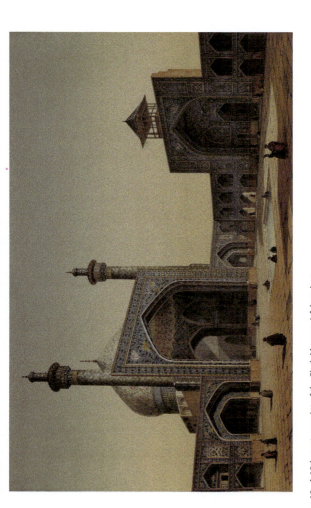

Figure 10. A 19th-century print of the Shah Mosque, Isfahan, Iran

This painting by French architect Pascal Coste (1787–1879) illustrates the courtyard of the Shah Mosque in Isfahan, Iran, known today as the Imam Mosque. The mosque's exquisite tiles used an innovative glazed technique, *haft-rangi* (seven colours), introduced in the early 15th century as a quicker and more economical process to achieve vibrant tile mosaics.

has made such an impression that it has become increasingly difficult to replace it with any other. It is possible that this deeply ingrained notion comes from a strong intimation that the dome and the minaret were always there, or at least were present relatively early in Muslim history, contributing to a sacred template, possibly even informed by the Prophet Muhammad himself. To determine whether there is truth to this, we must do some excavating.

The earliest version of the story we have received relates that it was in the year 622, 13 years after his mission had commenced, the Prophet Muhammad constructed his first *masjid* at the palm oasis of Yathrib, which would eventually become Medina. The common wisdom amongst Muslims and architectural historians is that the model and template for the earliest prayer space, and all subsequent structures, lie in the house of the Prophet. Attached to the Prophet's residence at Medina was one of the first spaces where he and his followers prayed. This first of spaces functioned as a gathering space, simultaneously a domestic environment as well as a *masjid*. The multiple uses of this space still can be seen in the way the mosque functions in many parts of the world today.

Of the primary sources in Islam – the Qur'an, authenticated *hadith,* and the earliest biographies (*sira*) of the Prophet – none provides a physical description of the size or layout of the structure that the Prophet adopted; at least, not an unambiguous rendering. We know little,

if anything, of a structure where the earliest followers of Muhammad might have prayed before this time. Despite this, a number of Western art historians have attempted to determine what this first of formal Muslim prayer spaces may have looked like.

The Italian scholar Leone Caetani (1869–1935), who travelled to the Muslim world and engaged in research and study of early Islamic sources, was one of the first orientalists to define the Prophet's Medinan mosque-home. Caetani's *Annali dell'Islam* argued that the square courtyard enclosed by a mud brick wall and pierced by three entrances, was largely domestic in its nature. According to Caetani, after the early Muslims complained of the heat and sun, the empty courtyard was furnished with a *zulla,* or awning, of palm trunks supporting a roof of woven palm branches and mud.

Keppel A. C. Creswell (1879–1974), the English architectural historian who was best known for his seminal works on early Islamic architecture, was the first to produce a comprehensive plan of the Prophet's mosque-home based on Caetani's model, detailing the 100 × 100 cubits wide square courtyard. Notably, Creswell introduced the arrangement of nine quarters on the eastern wall of the structure for the Prophet's wives. There have since been a number of subsequent efforts to modify the plan in attempts to understand the function and layout of the Prophet's mosque-home – in many ways this has proved somewhat futile and remains wrapped in layers of fantasy.

The years and decades after Muhammad's death in 632 gave way to the fledgling state's early rulers expanding and renovating the Prophet's home and adjacent space of prayer. First Umar and later Uthman, the second and third Caliphs who succeeded the Prophet as leaders of the early Muslim community, each in turn executed a new vision of the mosque. Finally, during the reign of the sixth Umayyad Caliph, al-Walid (r. 705–15), the entire structure was torn down and a new mosque was built in its place, incorporating the Prophet's tomb under a central green dome. All of these reconstructions make it extremely difficult to determine with any certainty or accuracy what the shape, ethos or function of the Prophet's original prayer sanctuary at Yathrib was like.

Despite this, evidence of Muslim ruins of the built environment and fragments of material culture still exist. The first Muslim prayer space for which an archaeological record exists was built in 703 in Wasit, a town in eastern Iraq. The brick mosque built for al-Hajjaj b. Yusuf (d. 714), a notorious politician and ruthless military leader in service of the Umayyad caliphate (661–750), gives us some evidence for the shape and structure of an early Muslim prayer space. The square structure supported by rows of columns on one side gave way to a slim band of similar pillars around the rest of the perimeter, all opening on to a central courtyard. This form was by no means the only architectural style prevalent in the early decades of the 700s. Other templates determined

from archaeological remains and literary frag-
ments also reveal alternative styles, forms and
motifs of these spaces, even when constructed
under the direction of a single individual.

The Umayyad Caliph al-Walid also oversaw
the development of a series of institutions which
included the building and expansion of a number
of prominent mosques. These ranged from the
renovation of the Great Mosque of Sanaa in
Yemen, to the Prophet's Mosque in Medina, as
well as the Great Mosque of Damascus, which
occupies a site long-devoted to worship, having
previously been occupied by a church dedicated
to John the Baptist. These structures were all
large enough for the congregational Friday prayer
(*salat al-jum'a*), the midday gatherings which
had become an important religious and social
event by this time. What was remarkable about
these and the dozens of other mosques built
during the 10 years of al-Walid's rule was their
great variety of proportions, materials, decora-
tion and construction techniques.

Although there is dissimilarity in form
between these disparate buildings, the ground
plans loosely adhere to what archaeologist Jeremy
Johns refers to as the 'concept of the mosque'.
This mental template or 'concept' which Muslim
prayer spaces would henceforth reference, seems
to have been fixed by the time the mosque at
Wasit was built. The template included a walled
enclosure at one end of which was a prayer hall
oriented on an axis towards the *qibla*, and a
central courtyard.

Over time, one predominant word became associated with these spaces: *masjid*, meaning a place of prostration. This term, originating from the Arabic dialect spoken by Muhammad and his tribe, the Quraysh, flowed into other languages spoken amongst inhabitants of the new Muslim polity. In more recent centuries, the word '*masjid*' became equated with a number of related words transmuted into the languages of Western Europe: 'mosque', 'mosquée', 'mesquita' and 'mezquita'.

The first step in understanding the complexities of the mosque's development would be to make sense of the relationship between the word '*masjid*' and the place to which it has come to refer. The Qur'anic revelation suggests that during the lifetime of the Prophet the term '*masjid*' did not yet refer to the mosque as we think of it today. The noun '*masjid*' and its plural, '*masajid*', appear 28 times in the Qur'an. In 20 of these instances the term references particular spaces. The phrase '*al-Masjid al-Haram*', which is presumably the Ka'ba, is mentioned 15 times. Also mentioned is '*al-Masjid al-Aqsa*', which later became associated with the Haram al-Sharif, or Sacred Sanctuary in Jerusalem.

Other uses of the term '*masjid*' in the Qur'an suggest a wider meaning beyond simply a mosque or prayer space. The Qur'an refers both to the Sanctuary at Jerusalem in connection with the Prophet's heavenly Night Journey (Q. 17:7) and to a structure built over the tomb of the legendary Seven Sleepers in the Cave (Q. 18:21) as *masjid*s. In yet another instance, in the chapter, or *sura,*

titled al-Hajj, the Qur'an refers to places of prayer more generically, alongside technical terms used in other traditions: 'Did not Allah check one set of people by means of another, there would surely have been pulled down monasteries, churches, synagogues, and mosques (*salawat* and *masajid*), in which the name of Allah is commemorated in abundant measure' (Q. 22:40).

On all these occasions, the Qur'an associates *masjid*s with sites belonging to religious communities in existence before Islam's advent. One *hadith* refers to an Abyssinian church as a '*masjid*', while another uses the term to describe Christian and Jewish tomb-sanctuaries. Even as late as the 14th century, the famous Tunisian historiographer Ibn Khaldun (d. 1406) still used the term in its generic sense.

All in all, reading the sources in this way suggests that '*masjid*', as understood by the Qur'an's audience in the 7th century, did not narrowly equate with a mosque in the sense of a prayer space used solely by Muslims. Rather, it may have been more generically associated with any place of worship, in the same way we might use the word 'temple' today. Evidently, at some point the Muslim place of prayer subsumed this broader understanding of '*masjid*', until it came to mean exclusively what we now call a 'mosque'.

Mosque Features

In the same way that the spire or belfry may be associated with church architecture, the minaret and dome remain tied to the mosque. How these

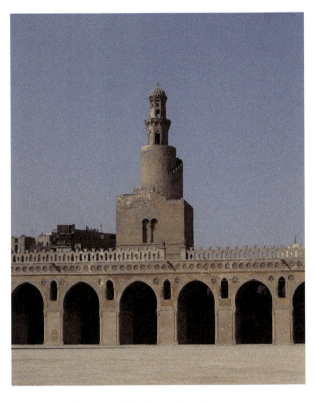

Figure 11. Ibn Tulun Mosque's Spiral Minaret, Cairo, Egypt
Built in 876–879, the Mosque of Ibn Tulun is reminiscent of Samarran style
architecture. In this view, one can see the brick piers with their crenellation. In
the centre of the image rises the spiral minaret, of uncertain date, which is the
only one in Cairo to have an external staircase.

elements became so closely associated with
the *masjid* in people's minds, as well as in archi-
tectural expression, is not entirely clear. Some
might argue that the call to prayer and the

increasing size of neighbourhoods, towns and cities which the mosque served, necessitated the higher towers for the human voice to reach more people. This argument, which may have credence in some circles, does not go far enough, however, to explain the need for such towers.

The first *muezzin,* or prayer-crier, was Bilal (d. ca. 682), an early adopter of Islam and a manumitted Abyssinian slave with a mellifluous voice. As far as we know, Bilal and other *muezzin*s never climbed a minaret or tower; rather, they stood in a public thoroughfare or on the roof of a mosque when reciting the *adhan* (call to prayer). These were places of shelter for the *muezzin,* and were denoted in early Islam by the terms '*sawma'a*' (literally meaning 'cloister') and '*mi'dhana*' ('place of the *adhan*').

Later, in the 8th and 9th centuries, formalized towers attached to mosques appeared. These were more commonly named *manara*s, meaning 'a place of light', from which the term 'minaret' derives. The minaret, in its varied cuboid and spiral forms, is often deemed synonymous with the place to call the faithful to prayer; however, recent scholarship has proposed that this association is somewhat misleading given the various contexts in which a minaret may have functioned, including its significance as an emblem of power. Today, the oldest surviving minaret lies on the western edges of the Muslim world in what is now Tunisia. The Great Mosque of Qayrawan, also known as the Mosque of Uqba, is one of the oldest surviving mosques in the

Figure 12. The *Mihrab* and *Minbar* in the Mosque-Madrasa of Sultan Hasan, Cairo, Egypt

The *qibla-iwan* of this spectacularly large *madrasa*, mosque and mausoleum, built by the Mamluk sultan Hasan during his second reign, at the foot of the Citadel. This view shows the original polychrome marble dado, the elaborate *mihrab* with its interlocking joggled voussoirs in alternating colours and repurposed Crusader columns from Palestine, the unusual stone *minbar*, and Kufic inscription band.

Muslim world. The Great Mosque had its first stones laid in 670, yet it was only in 836, after a number of extensions, that the mosque saw its imposing minaret added to its enclosing walls.

Similarly, the dome has come to exist as an essential mosque feature. Its appearance in early Islamic architecture, however, was not only in association with the mosque; rather, it was a prevalent feature among many caliphal palaces. For example, the palace at the Umayyad capital of Wasit, Iraq, featured a dome, as did Abu Muslim's (d. 755) palace in Merv, in present-day Turkmenistan. Thus the dome can also be understood as an extension of a ruler's dominion, influenced by regional and political factors, as well as architectural symbols associated with the mosque.

From the variety of mosque forms throughout the world, we realize that the minaret, and its sister structure, the dome, are not intrinsic parts of the mosque architecture. Their absence in the mosques of certain cultures further suggests that they may not have been viewed as essential elements until more recent times.

The interior features of the mosque are no exception to the rule of diversity seen thus far. However, there are a number of attributes found inside a mosque that are shared worldwide. The first and most notable is the *mihrab*, a niche or inset in the mosque's most important wall, usually opposite its entrance, which indicates the direction of prayer. The *mihrab* is a feature which decorates the walls of the majority of the world's

Figure 13. Şakirin Mosque, Istanbul, Turkey

While traditional in its function, the Şakirin Mosque in Istanbul offers a modern twist to interior mosque features. Built in 2009, the mosque features a *minbar* adorned with an acrylic leaf motif, while the striking gold and blue *mihrab* reveals an abstract form of the traditionally arched prayer niche.

mosques, from the most simple and austere to the highly elaborate. In the most ornate of mosques, it is bordered by calligraphy and decorated with elaborate stone, marble or tilework, or pictures of the Ka'ba at Mecca. In larger mosques or ones that cater to different Muslim communities, multiple *mihrab*s may also be present along the same wall or on different pillars, indicating the same direction of prayer.

In larger congregational mosques, there is often also a *minbar*, a stepped platform similar to a staircase, used by the imam, the prayer leader, or the *khatib*, the person offering the sermon, raising him above the congregation during his weekly exhortations. Occasionally mobile, supported on wheels, *minbar*s can be ostentatious, engraved with floral motifs and designs, topped with regal parasol-type structures or simply made of unadorned wooden beams.

Beyond these consistent features, there is much variety within mosque spaces. In early Damascene mosques, one sees the *maqsura*, which shares its linguistic root with the Arabic word for palace. The *maqsura* is a screened enclosure designated for the caliphal entourage, separating the caliph and his entourage from the masses. Similarly, in Turkey, Ottoman mosques made provisions for the sultans with balconies within the interior of the mosque known as *hunkar mehfili*.

Amongst the Hui Muslims of China, there is a tradition of a narrow wooden structure, known as *bayt al-itiqaf* (the abode of retreat), placed at

Figure 14. KAPSARC Community Mosque, Riyadh, Saudi Arabia

The King Abdullah Petroleum Studies and Research Center (KAPSARC) was established in 2013 to conduct research into energy and environmental policy. Its community mosque pictured here is situated in the centre of the site, offering a contemporary interpretation of a mosque. The glass cube structure comprises the main prayer hall that sits beside the stone-cladded minaret, complementing one another in their display of abstract motifs.

the corner of the mosque for the imam to sequester himself outside of formal prayer times – to engage in personal piety, to read the Qur'an and ethical texts, as well as to pray for his entire congregation. We also know that small rooms in minarets were traditionally used as spaces for spiritual retreat, particularly in the case of North African minarets. Similar spaces of retreat are found today amongst many mosques in the northern reaches of the Central Asian Republic of Tajikistan. In the former city of Leninabad, now Khojand, underground rooms beneath mosque carpets and floorboards provide a space for those who wish to undertake a period of temporary retreat. In other parts of the country, these sanctuaries of solitude are located in graveyards adjacent to mosques.

With these varied features of the mosque, in both its exterior and interior, we are reminded of the equally varied expressions of piety that the mosque is home to across the world. While the Prophet's home and prayer space was a reasonably modest affair, more monumental structures emerged with the caliphal expansion of the lands under Muslim control. Whether adapting pre-existing structures or creating new ones, it is mainly local culture and economic and political power which contributed to the moulding of these *masjids*.

Even today, in the face of globalization and communal self-consciousness, religious buildings continue to pay homage to traditional and local practices, such as those in West Africa

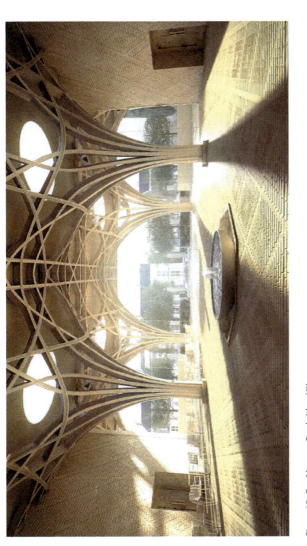

Figure 15. Eco Mosque, Cambridge, UK

Architect's rendering of Britain's first eco mosque, built to serve as a spiritual, social and educational hub for the estimated 6,000 Muslims in Cambridge, UK. Emphasizing the significant relationship between faith and the environment, the design of the mosque promotes low carbon emissions and the responsible use of natural resources.

and China, alongside those buildings which comfortably sit within imaginative forms of experimentation. In contemporary times, a new trend is also developing amongst modernist architects of religious buildings: one whose very enterprise is to challenge traditional models. We have seen this occur in places such as Istanbul with the Şakirin Mosque, the first mosque in Turkey to be designed by a female architect, Zeynep Fadillioglu. Challenging interior norms of a mosque, Fadillioglu offers a contemporary interpretation of traditional Islamic art, while providing equal prayer space for women and men. The Şakirin Mosque also boasts very low carbon emissions among Turkish mosques today. Similarly, Cambridge, England, is home to a purpose-built energy-saving mosque, termed an 'eco mosque'. Utilizing natural light and the latest conservation technology, the eco mosque is the first of its kind in Britain. While the mosque continues to be an emblem of tradition, the adaptation of this space of worship is as much determined by the community it serves as by the environment and time.

Chapter 2

Mosque Practices

The *Salat*

The mosque, wherever its location, is most readily associated with a single ritual above all else: the *salat*. *Salat* – or *namaz,* as it is denoted in the Persian-speaking world and Indian subcontinent – constitutes worship or prayer. In the later years of the Prophet's life, the term became synonymous with a particular formalized expression of piety with prescribed conditions and postures. Today this is associated with the daily prayer, which structures the lives of many Muslims across the world up to five times a day. While there are slight variations in this prayer between one *madhhab* (schools of Islamic jurisprudence which developed some two centuries after the Prophet's death) and another, between Sunni, Shi'i, and Muslims of other persuasions, the *salat* is a recognizable and unifying act amongst the majority of Islam's adherents.

Muslims know and understand the *salat* to be a prayer of submission and thanksgiving to the Almighty God, or Allah. While the prayer often takes place in congregation, the *salat* is a deeply intimate and spiritual act, combining bodily movements and vocal utterances that are

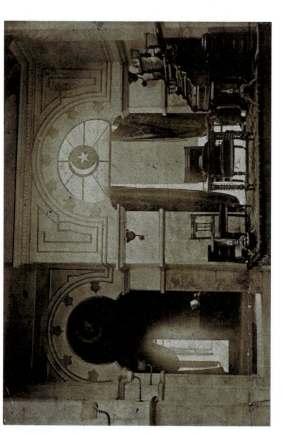

Figure 16. Interior of the Liverpool Muslim Institute, UK

Unassuming in its appearance as a terraced house, Brougham Terrace in Liverpool is home to Britain's first functioning mosque. William Quilliam, an early convert to Islam, established the Liverpool Muslim Institute in 1889, which he developed to incorporate a boarding school, orphanage, and even a publishing house that notably published *The Crescent* newspaper, the first publication to serve the Muslim and convert community in the UK.

rooted in the Prophet Muhammad's own prayer to God. These are communicated from one generation to the next through observation, participation and internalization. The series of gestures during the ritual – in all its iterations – include standing, bowing, kneeling and prostrating. During these actions, Arabic passages from the Qur'an are recited.

The *salat* is a distinctive act. The timings of the prayer are aligned with the various rhythms of the sun: pre-dawn (*fajr*), shortly after the height of the sun at midday (*zuhr*), the afternoon (*asr*), just after sunset (*maghrib*) and around nightfall (*isha*). Many Muslims in the world diligently observe this daily practice to some degree of variation determined by culture, community, and *madhhab*.

In preparation for prayer, men and women perform a ritual washing or ablution (*wudu*) in which the face, hands and feet are cleansed, following a prescribed manner whose basis can be found in the Qur'an. The *salat* itself involves between two and four ritual cycles, known as *rak'as* – the number being dependent on the circumstance and time of day. Each *rak'a* usually consists of a sequence of bodily postures beginning with standing (*qiyam*), bowing with one's feet on the ground (*ruku*), and prostration with one's hands, knees, and forehead in contact with the ground (*sujud*). The final *rak'a* culminates with a longer posture of kneeling (*qa'da*), followed by greetings and blessings of peace to fellow congregants.

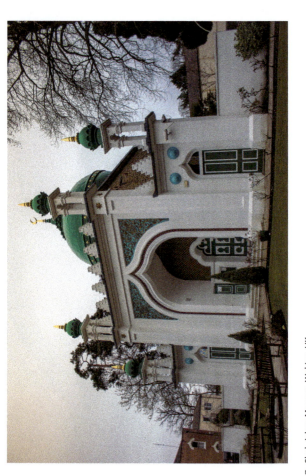

Figure 17. Shah Jahan Mosque, Woking, UK

Established in 1889 as Northern Europe's first purpose-built mosque, the Shah Jahan Mosque was frequented by the likes of Marmaduke Pickthall (d. 1936), an eminent Islamic scholar and early translator of the Qur'an into English.

While the *salat* can be performed at home or alone in the mosque, there is religious and social merit to praying in congregation. To accommodate congregational prayers, a larger form of the mosque emerged that can often be found in any large town or city in the world that is home to a Muslim community: the *masjid jami'*. Derived from the Arabic word meaning an 'assembly' or 'gathering', the *jami'* refers to larger spaces used to hold the especially auspicious Friday midday prayers. The *jami'* also tends to serve as one of the central hubs of Muslim affairs for a city, representing the community regionally, nationally, and sometimes even internationally, proving particularly significant for diasporic communities in the West.

One such example is London's Central Mosque, otherwise known as Regent's Park Mosque. Built in 1977, the mosque, along with the adjoined Islamic Cultural Centre, came into existence with the support of worldwide donations, acknowledging the need for a hub for the British Muslim community, which it continues to serve today.

Interestingly, although Britain has enjoyed a long association with Islam, the first mosque in Britain was established only in 1889 in Liverpool. It is notable that this was founded by an English convert, William Quilliam (d. 1932), rather than by a migrant community. At the same time, the first purpose-built mosque, the Shah Jahan Mosque, was commissioned by the Jewish-born Hungarian orientalist, Gottlieb Wilhelm Leitner

(d. 1899), in Woking, Surrey. From these two examples alone, we see hints of the deep impact that Muslim spaces can have beyond a proximate Muslim context.

At Regent's Park Mosque, as with other congregational mosques across the world, Friday prayers are preceded by a sermon known as a *khutba*, delivered by someone knowledgeable in the faith – often the same person who leads the prayer. Those gathered face the same direction, orienting themselves towards the *mihrab* wall located at the front. During times of congregational prayer, those present will stand shoulder to shoulder in straight lines spanning the entire breadth of the mosque. For female congregants, the mosque was designed to feature a balcony that overlooks the main prayer hall, accommodating up to 5,000 worshippers in total. During other propitious occasions, including evening prayers during the holy month of Ramadan and the *salat* performed on Eid al-Fitr (Festival of Breaking the Fast) and Eid al-Adha (Festival of Sacrifice), *jami*'s across the world welcome hundreds and thousands of worshippers; Regent's Park Mosque is no exception.

Thus, in one form or another, the *salat* is entwined with the mosque's space, be it the larger *jami*'s, or smaller local *masjid*s. This is not to say, however, that the *salat* is the only prayer that takes place within a mosque, for the mosque houses a range of devotional acts that vary from place to place. The mosque can act as a space for conversation, for education, for

Qur'anic or religious study, for meditative prac-
tices, or simply as respite from the sun's heat or
the winter's cold. A social avenue for neighbour-
hood news and chatter, the mosque can also be
the vehicle through which a government shares
its political agenda through postings or via the
weekly sermon. Moreover, it is a venue to celeb-
rate a birth, marriage, or return of a loved one
from *hajj*, as well as a place to mourn the recently
departed.

On my journey, it became apparent that there
are as many mosques as there are communities.
Drawing upon the social and religious life of other
mosques, a mosque distinguishes itself through
the way in which its particular community util-
izes it. To understand how a mosque is further
shaped by the rituals that are specific to the
community it accommodates, we must first grasp
the nuances across the breadth of the Muslim
world, beginning with perhaps the most recog-
nized distinction in the spectrum of Muslim
communities: that of the Sunnis and Shia.

The Emergence of Sunni and Shi'i interpretations

Following the death of the Prophet Muhammad
in 632, the early period of Islam marked an intel-
lectually and spiritually rich era, where debates
amongst Muslims resulted in the development
of theological and legal schools of thought,
many of which would later form the basis for a
series of defined communities. The most far-
reaching debate concerned the nature of political
and religious authority after the Prophet's death

and occupied the laity as well as the intelligent-
sia of 7th- and 8th-century Arabia and beyond.
As a result, the Sunnis and the Shia emerged.

The expression 'Sunni', derived from the
Arabic, *ahl al-sunna wa'l-jama'a* (people of
the tradition and the community), referred to
those early Muslims who believed that succes-
sion to the Prophet resided in a series of the
early companions who became acknowledged
as caliphs. In time, those who were united
through this belief and common conception of
authority became associated with a communal
identity as Sunni Muslims. Among Sunnis, there
are different *madhhab*s (schools of legal inter-
pretation) and cultural customs. Demographers
place Islam's Sunni adherents at about 85% of
the Muslim world – by far the vast majority.

As for the Shia, similarly this label was
later used to denote the group of believers who
supported the succession of Ali b. Abi Talib,
otherwise known as the *Shi'at Ali* (the partisans
of Ali). While Sunnis recognise Ali as the fourth
Rightly Guided Caliph, the Shia believe that the
Prophet himself had designated Ali, his cousin
and son-in-law, as his successor: a sacred duty
that was ordained and commanded by God. This
is believed to have been divulged by the Prophet
at a place known as Ghadir Khumm while
returning from Mecca on his final pilgrimage.
Within the Shi'i branch of Islam, there are also
subgroups. These include the Ithna'asharis (or
Twelvers), the Ismailis and the Zaydis, amongst
others. While Sunni and Shi'i Muslims may

differ on the nature of post-prophetic authority, they share much in common and equally contribute to the definition of what it means to be a Muslim. In time, as communal identities solidified and subgroups formed amongst them, theologies, authority structures, and often doctrines were also recast in response to the circumstances in which these divisions emerged.

At the heart of the formation of these communal identities lies the mosque, and specifically the rituals and practices that it houses for both Shi'i and Sunni communities. Through my journey to the Mediterranean city of Beirut in Lebanon and one of Africa's largest cities, Cairo, the diversity in these practices began to unfold.

Lebanon and Shi'i Ithna'ashari Mosque Practices

Lebanon's Shi'i Muslims are almost exclusively Ithna'asharis, or Twelvers. This branch of Shi'i Muslims is named so because of the number of hereditary spiritual leaders or Imams believed by its followers to have succeeded the Prophet. They believe that upon the death of the 11th Ithna'ashari Imam, Hasan al-Askari (ca. 846–874), his son Muhammad al-Mahdi inherited his father's position as the 12th Imam. However, due to several generations of persecution by the ruling Abbasid dynasty (750–1258), Muhammad al-Mahdi went into hiding, entering a state of occultation (*ghayba*). To this day, the Twelver Shia believe that the Imam remains in this state, being still present in this world until he appears at an undisclosed time in the future to resume

his rightful position of leadership. During his period of occultation, the task and responsibility of responding to the myriad concerns of his followers lies in the hands of an *ayatollah* or *marja taqlid*, the most learned scholars and clerics of Shi'i jurisprudence who are qualified to interpret the law.

Today, the Beirut neighbourhood of Haret Hreik is firmly associated with Ithna'ashari Shi'i Islam. In it lies the largest structure in the city's southern suburbs, the Congregational Mosque of Imams Hasan and Husayn (*Jami' al-Imamayn al-Hasanayn*) catering to the faithful who come here to pray. It is named after the grandsons of the Prophet Muhammad, who became the hereditary spiritual leaders of the Shi'i community following the assassination of their father, Ali, in 661.

With separate entrances for men and women, and a large stationery shop built into the structure, whose rent supports the upkeep of the religious institution, the mosque's massive proportions overshadow any other structure in southern Beirut. The space, able to accommodate thousands of people, is divided into two levels. The upper level is reserved for women, who are able to see the lower floor through a wooden balcony screen. A large inner dome contains the names of the Twelver Shi'i Imams, with quotations ascribed to them alongside Qur'anic verses adorning the entire length of the octagon.

On my visits to the *Jami'*, the prayer hall was adorned with black banners beseeching Imam Husayn for his intermediation in this world,

while a split-level *mihrab* and *minbar* duo was flanked by two painted scenes on canvas depicting Imam Husayn's martyrdom in 680. Commemoration of this tragic event marks one of the most spiritually potent days of the year for many Shi'i communities. Imams in the Shi'i tradition do not just assume political or spiritual leadership; rather, they are believed to have been divinely sanctioned by God to provide inspired guidance and spiritual leadership.

Like other Shi'i congregational spaces in the city, the mosque is open for the daily prayers. There are also additional supplications, or *du'as*, after each of the *salats*. Through the words of their Creator and His final Prophet, Shi'i Muslims find meaning in this world and translate this into liturgical and ritual activity, giving prominence to the Imams whose special lineage and bloodline both link them to the Prophet and ascribe them with Divine favour. One of these practices, known as *ziyara*, meaning a 'visit', involves greeting the Prophet and each of the Twelver Shi'i Imams. During this act of devotion, standing congregants face the direction of the graves in which the Prophet or the Imams are buried, in Arabia and Iraq respectively, and re-orient themselves in the direction of each deceased Imam. In the same way that the *qibla* determines the direction of the *salat*, the location of the Imam's grave determines the direction the supplicant faces when he calls a particular Imam's name. The Imams' names are invoked in sequential order, from the first Imam, Ali, to the present Imam, in the direction of *qibla*,

who remains in a state of occultation. In each invocation, the Imam's praises are extolled and his favours are sought. The *ziyara* offers a benefit similar to, but lesser than, paying one's respects to the physical tomb of an Imam and carries the weight of a duty.

In addition to the *ziyara*s that are recited daily, other supplications are made throughout the year on special anniversaries related to the birth or death of an Imam or members of the Prophet's family, the *ahl al-bayt,* or the Household of the Prophet. Moreover, a prominent prayer known as the *Du'a Kumayl* is recited by many Shi'i congregations on Thursday evenings after the *salat al-maghrib*, the dusk prayer. At the *Jami'*, Thursday evenings have historically also included a *majlis,* or gathering, of the *marja taqlid* in which he addresses the congregation in the form of a didactic sermon. The addition of these elements to the Thursday roster makes it a time in which many congregants come to take advantage of the spiritual and educative offerings available, in addition to the social opportunities congregational prayers provide. For some, the effect can be very powerful, often resulting in tears for the supplicant. In this moment where time is almost suspended, prayer is infused with a renewed sentiment and meaning.

Sunni Devotion to the Prophet and his Family: Cairene Mosques

While the figure of Imam Husayn is most readily associated with Shi'i Islam, he remains

significantly revered by all Muslims as the beloved grandson of the Prophet Muhammad. In particular, the Sufi tradition, which can best be understood as an esoteric orientation within Islam, often traces its doctrines from the Prophet through his son-in-law Ali, and thus also reveres Ali's son Husayn. In fact, members of the *ahl al-bayt* are widely acknowledged by Sufis for their role in founding the majority of Sufi orders that exist today, and this reverence has permeated the cultures and traditions of numerous Sunni communities and Sufi orders

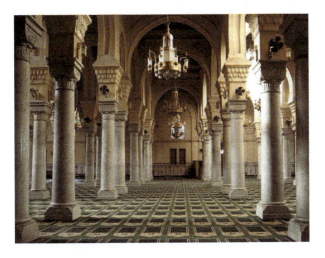

Figure 18. Mosque of Sayyida Zaynab, Cairo, Egypt

This mosque, believed to have been built over the grave of Zaynab, sister of Hasan and Husayn, remains an extremely popular place of visitation for Sunni and Shi'i Muslims alike. The current mosque was completely rebuilt in 1940 in the anachronistic fin-de-siècle eclectic style favoured by Khedive Abbas II. This view shows the extension added by the Egyptian government in 1969.

across the world. On my visit to Cairo, where the vast majority of its approximately 19 million inhabitants are Sunni Muslims, this deep devotion to the family members of the Prophet was evident in local mosque practices.

Notably, a number of important mosques located in the city are believed to have interred the remains of certain descendants of the Prophet. While men of repute and lineage can be found in mosque-tombs, it is those most closely aligned with the Prophet's lineage who are believed to carry blessings, or *barakat*, along with those endowed with the divine favour of God, otherwise known as saints, or *awliya*. Partly due to the sanctity associated with these individuals and their respective resting places, discrepancies often arise concerning the claimed whereabouts of particular tombs, which has resulted in multiple sites attributed to the same person or relic.

With Cairene mosques in particular, notable women, considered patron saints of Cairo, are often commemorated. These include Sayyida Nafisa (d. 824), the great-granddaughter of Hasan, and Sayyida Ruqqaya (fl. 680), a daughter of Ali. While the mosque-tombs of both these women are frequented by those praying for intercession, it is the Mosque of Sayyida Zaynab (*Masjid al-Sayyida Zaynab*), dedicated to Husayn's sister Zaynab (626–682), that remains the most prominent of the mosque-tombs in Cairo devoted to a woman. As the granddaughter of the Prophet Muhammad, Sayyida Zaynab is a significant member of the *ahl al-bayt,* and is considered a steadfast protector of

the Prophet's bloodline, having saved the life of Husayn's son Ali Zayn al-Abidin (ca. 659–713). The suffering and grief she experienced in her lifetime, through the death of multiple family members at Karbala and her own experience as a captive of war, has made Zaynab a figure closely associated with human suffering. Similarly, her defiance in the face of tyranny, as exemplified in her eloquent public sermons, has remained inspirational to Muslim worshippers worldwide. This can be seen in Egypt today, with Zaynab's death anniversary attracting more than two million people to her shrine in one of the country's largest religious observances, known as *al-layla al-kabira,* or 'the great night'. Similar gatherings take place in Syria, where Damascene worshippers also claim Sayyida Zaynab's body is interred.

The mosque-tomb in Cairo hosts weekly *hadra*s (collective gatherings devoted to acts of remembrance) in which devotees may come to offer prayers and supplications in the presence of the deceased in the hope of obtaining some kind of intercession or blessing. For many Muslims there is a sense that even after an individual dies, the grace that they exhibited in their lifetime survives death and is associated with whatever they came in contact with: be it their body, a comb, or a preserved imprint of their foot. In the case of a *wali*, or saint, it is often believed that they are able to intercede in everyday matters, be it healing the sick or marital troubles. Some Muslims take this opportunity by visiting shrines and tombs, asking for the blessings of

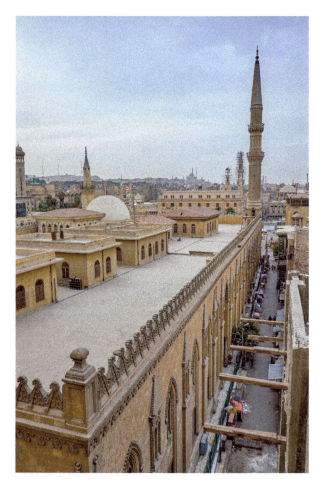

Figure 19. Mosque of Sayyidna Husayn, Cairo, Egypt
Believed to contain the relic of the head of Husayn, this is considered one of the
most sacred sites in Cairo. The current building is a late 19th-century structure
which appears to incorporate Gothic features. The mosque is the focal point of two
hugely popular annual festivals, the *mawlid*, or birth, of the Prophet and the
mawlid of Imam Husayn.

God through the favour of those interred, and to be touched by the grace that exudes from their presence, even after death. As a result, weekly and yearly acts of devotion, pilgrimages to the sites and large festivals known as *mawlid*s all take place in and around the enclosures of Cairene mosques that protect the relics.

On the edge of the Khan al-Khalili souk, the commercial heart of Historic Cairo, lies the country's national mosque, the Mosque of Sayyidna Husayn. Bearing much in sentiment with its namesake in Beirut that accommodates the Ithna'ashari community, the Mosque of Sayyidna Husayn in Cairo attracts its predominantly Sunni population. Traditionally, the mosque was the preferred place of prayer for Egypt's presidents-past, with its precincts today remaining a vibrant hub of Cairene life. The mosque is of significance not only because of its national status, but because it houses what is believed to be the head (*ra's*) of Husayn. Conflicting accounts of different groups mean that various sites are attested as the *maqam ra's al-Husayn* ('the sanctuary of Husayn's head'). In this case, it is said that the sacred relic was moved to a tomb in Egypt from Asqalan in Palestine in 1153, following the Fatimid Empire's (909–1171) establishment of Cairo as their capital in 973. As a result, the mosque has remained a major site of worship, serving as a space to perform daily prayers and partake in the blessings of the *ahl al-bayt,* as well as attracting thousands of men and women each year to commemorate the birthday, or *mawlid,* of Husayn.

Like most mosques in Egypt, the Mosque of Sayyidna Husayn invites both men and women to pray, in separate sections, and teems with people on Friday at midday for the congregational *salat*. The *khutba* is delivered by an imam of the mosque, or a *khatib* (an orator who specializes in these Friday exhortations), or sometimes even a celebrity guest. The short 15-minute speech can deal with a wide variety of topics, from religion and ethical living to stories of the Prophet and his companions. After this, the formal *salat* begins.

What happens next, however, might be somewhat foreign to those who have never been to one of Cairo's tomb-mosques. Scattered throughout the space, small groups of men gather together to form circles, standing or seated, and begin to recite devotions thanking God and praising the Prophet. The devotions take the form of *dhikr*, or formulas of invocation, as well as sung poetry. The closer one's group is to the tomb, the more grace one is said to receive. Each group – and there can easily be anywhere from 12 to 18 depending on the week – has its own loosely aligned way of practising, according to the mystical inclinations of its individuals. These groups jostle for proximity to the tomb, carrying banners and signs, while announcing themselves to others. The rituals strike a chord with most that are present. It is an opportunity to recite their recommended prayers while at the same time engaging in a more intimate group prayer with peers. At the allotted time, the mosque is

filled both with the presence of many adherents and with sound, as God's praises rise above the din and chatter of the expansive building.

In Cairo, as elsewhere, the mosque is a space which comes alive through its rituals. Through these rituals, Muslims express their piety and demonstrate their local histories and cultural understandings of Islam. By exploring mosque rituals, we begin not only to see the social and intellectual history of the people who frequent these spaces, but we also learn much about the different ways one can be Muslim. While our preconceptions of Muslim communities around the world might determine how we envisage the use of certain mosque spaces, as we have seen in Cairo, variation of ritual can exist within a given group of Muslims, and at times can have more in common with another group than one might assume.

While the mosque is considered one of the most visible symbols of Muslim presence and the *salat* its predominant ritual, it is clear that mosque practices are as varied as its architecture. If we begin to look beyond the mosque itself, we find a wide range of religious spaces that accommodate the spiritual and educational lives of Muslims across the world. In the next chapters, we begin to explore these additional constellations of piety and practice.

Chapter 3

Shi'i Sites of Piety

Shi'i Islam, like Sunni Islam or Sufism, is not a homogenous category. Rather, it comprises a number of communities with different interpretations of certain issues – Ithna'ashari, Ismaili, Zaydi – but also by the cultures that these expressions of theology speak through, be they Persian, Arab, or South Asian.

The emergence of Shi'i communities as bounded entities with distinct beliefs and rituals can be traced back to the 8th or 9th centuries. Before that, very little distinguished the two groups that would later be defined as Sunni and Shia, especially in the domains of practice. With the increasing focus and development of Shi'i theology around the Imams, visits to their shrines became one of the first elements that distinguished Sunni and Shi'i Muslims from each other.

In the Shi'i model, the institution of the imamate adhered to a particular familial line whose key genealogical nodes linked back through a chosen line of Imams to the Prophet and his daughter Fatima (615–632). Essential to these considerations of leadership was lineage and specifically bloodline, for blood in medieval understandings carried with it, not only the

material link of biological identity that modern science describes today, but good character – noble blood – that would be transferred from one generation to the next. In Muslim readings, it was the Prophet's exemplary moral character, inherited through the bloodline of his own ancestors that opened the way for him to be chosen to receive the gifts of prophecy and revelation.

For Shi'i Muslims, Muhammad's role as *rasul Allah*, God's messenger who receives the revelation, is exclusively his. The Imams are vested with exclusive knowledge and prerogative to interpret God's word and make it relevant to subsequent generations. Thus, the ability to guide and lead contemporary Muslims is entrusted to the line of Shi'i Imams, continuing the prophetic bloodline. Shi'i Muslims regard Ali as the Prophet's successor designated by him under divine command; in emulation of this, it is the duty of each Imam to designate the next Imam. This concept, known as *nass*, was developed in the formative period of Islam. Acknowledging the Imam's right to succession and his spiritual authority remains a principal belief of Shi'i Islam, and is termed *walaya*.

Amongst many Shi'i communities, it is the near loss of this spiritual leadership just two generations after the Prophet's death and the subsequent sadness and regret over internal strife within the *umma* that have become the focus of Shi'i traditions of piety. Specifically, the Battle of Karbala in 680 waged by the second Umayyad Caliph, Yazid I (r. 680–683), which culminated in

the martyrdom of Imam Husayn and his entour-
age. This historical tragedy, which shaped Shi'i
ethos and identity, has generated rituals of grief,
repentance and remembrance, along with spaces
to house these acts of piety. These spaces are
most often called *husayniyyas*, after the person
who inspired them, but they also take other
names such as *takiya* and *ashurkhana* amongst
Shi'ism's different cultural groups. Each, while
united in commemorating Imam Husayn, has its
own distinct rituals and symbols that bring the
faithful together in mourning. While the most
heightened of these acts of piety take place in the
first month of the Muslim calendar, Muharram,
many of these spaces are used throughout the year
to observe the death anniversaries of members of
the Prophet's family and the lineage of Shi'i Imams
who succeeded him. These spaces are predomin-
antly used by the largest Shi'i community, the
Ithna'asharis, or Twelvers, who number, by many
estimates, more than a quarter of a billion people.

Iran's *Husayniyyas* and *Takiyeh*s

Iran, with a burgeoning population of 75 million
and an area three times the size of France, has
land borders with seven different countries
and is what some refer to as the world's only
theocratic state. Its remarkable history and the
cultures with which it has come into contact
have contributed to the diversity of its inhabit-
ants. Today, the vast majority of its population
define themselves as Ithna'ashari Shi'is. In the
northern and western parts of the country, sites

Figure 20. Mourning Ceremony in a *Husayniyya*, Yazd, Iran
Male worshippers perform *matam* rituals during the holy month of Muharram
in the Fahadan Husayniyya in Yazd. The prevalent use of green is a common
feature of Shi'i iconography for its association with the *ahl al-bayt*.

for religious observances are usually referred to
as *husayniyya* or *takiyeh* (otherwise known as
'*takiya*' in its Arabic form). In most cities in Iran,
the *husayniyya* is located in a central location
close to the *bazar,* or marketplace, which is
the central focus of the city during Muharram.
While many *husayniyya*s remain independent,
others are coupled with *masjid*s or educational
and political institutions.

In general, three types of ritual take place in an
Ithna'ashari *husayniyya*. The first is the *ta'ziya,* a
ritual in the form of a passion play that re-enacts
the tragic demise of Imam Husayn, where his
family and enemies are characterized, often using

Figure 21. Depiction of the Battle of Karbala from the Qajar Period

An oil on canvas painting by Abbas Al-Musavi dating from late-19th to early 20th century Iran. The painting depicts the events of Karbala; the figure of Abbas (centre), Imam Husayn's half-brother, appears mounted on a horse while defeating a member of the Umayyad's military campaign.

the scripted text of the *maqtal-namas*, a genre of literature in which the tragic events of the month of Muharram are recounted. The second is the *sineh-zani,* or chest-beating with one's hands or sometimes even chains, which is a form of gestural mourning that is collectively known as *matam.* Other forms of *matam*, more commonly observed in South Asia and Lebanon, involve the use of implements. The third ritual to take place in the *husayniyya* is the *rawzeh-khwani,* which involves the mournful narration of Imam Husayn's martyrdom in song. There are also *majlis*es in which sessions of tears and sorrow, *aza-dari,* take place either in the *husayniyya* or at home. Here the communal and social expressions of grief find an outlet, and during Muharram often blurs the lines of segregation between men and women, as collective grief binds the community. This reaches its height on the 10th day of Muharram – Ashura – which commemorates the martyrdom of Husayn, and is considered a national holiday in places such as Iran.

*Husayniyya*s and *takiyeh*s often differ from *masjid*s in that they must be able to accommodate the large crowds that attend the Muharram observances and the various rituals that are performed. Unlike the *masjid*, they are not oriented towards the *qibla*, nor is a wall indicated or marked. Many have a stage or theatre to accommodate the *ta'ziya,* and an open courtyard or foyer where the mourning ceremonies occur.

One striking difference between many Ithna'ashari buildings in particular and buildings

of other communities, including Sunnis, is the presence of images. On my visit to the Takiyeh Mu'aven al-Mulk in Kermanshah, western Iran, the walls were covered with glazed tiles depicting religious scenes, as well as images of historical figures. Here the history of Islam and its insertion into a broader Persian history, which both precedes and envelops the religion, are visually captured, be they the images of the prophets found on the upper walls of the Takiyeh, the events of Karbala, or famous Iranian kings and scholars from both ancient and modern dynasties. The sensitivities that exist amongst some contemporary Muslims about visual depictions of the Prophet Muhammad do not apply to the representations of Imams. In fact, visual culture, and in particular representation of the Imams or other founding figures, is often an essential part of the Shi'i decorative arts, and it is common for *husayniyya*s and *takiyeh*s to depict individual personalities or scenes related to early Muslim history – sometimes even political personalities.

India's *Ashurkhanas* and *Imambaras*
A significant number of Ithna'ashari Shi'is in India reside in the northern city of Lucknow. One of the few cities in the country with a Shi'i majority, Lucknow is home to monumental structures called *imambaras* dedicated to Imam Husayn and the events of Karbala. The southern city of Hyderabad, on the other hand, has a minority Shi'i population and has similar monuments known as *ashurkhanas*, which are

Figure 22. Painting of a *Ta'ziya* Procession
Produced in the early 19th century, this watercolour painting depicts a
procession of mourners in the Indian subcontinent bearing *ta'ziyas* during a
Muharram procession. Typically these structures are submerged into a local
river or sea as part of the procession.

significantly more modest than their Lucknawi
counterparts. Ultimately, both spaces are dedi-
cated to the Prophet's grandson, his tribulations,
as well as other members of the *panj tan* (the
five noble figures that according to the Shia form
the lineage of the leadership for the Muslim
community: the Prophet Muhammad, Fatima,
Ali, Hasan and Husayn). Despite differences in
scale, the spaces in both cities are the focal
points and rally large processions during the
month of Muharram with its associated rites and
observances.

As part of these occasions, *tabarruk* (blessed objects) and sacred relics have a significant part to play in the sanctity of the month's events and give importance to the spaces themselves. Unlike the Iranian understanding of the term '*ta'ziya*' as passion play, the Indian usage of the word refers to the bamboo, paper, silver or gilt renditions and models of Husayn's mausoleum or shrine at Karbala. Many of the *imambaras* and *ashurkhanas* across India have permanent versions of these on display, usually quite ornate in nature. Portable *ta'ziyas* are usually made from bamboo and paper before the annual procession and then ritually disposed by submersion in a pool of water or river on the day of Ashura.

While the *ta'ziya* is an essential element of these spaces, one might also see a *tabut* – more so in the *imambaras* – which, as a model of Husayn's tomb, occupies the larger spaces. Unlike the *ta'ziya*, the *tabut* does not have a ritual function but acts as a reminder of the events at Karbala and Imam Husayn's sacrifice and compassion. Similarly in these spaces there are *alams*, standards, whose usually silver poles are crowned with emblematic shapes inscribed with the names of the *ahl al-bayt*. A common motif on the *alam* is the open hand with the engraving '*Ya Husayn*' (O Husayn!) on its palm. In the Shi'i context, this emblem is called the *panj*, symbolically referring to the *panj tan,* while in other Muslim contexts, particularly in North Africa, it holds talismanic significance as the Hand of Fatima, in reference to the Prophet Muhammad's

daughter. *Alam*s would have originally been used to tie Husayn's insignia or the flag of his party and might possibly have been handled by him, his family or his supporters in battle. Thus these relics are considered sacred by many of the congregants who yearn to come in direct contact with them during the Muharram observances. Like that of shrines of holy figures, the blessing (*baraka*) that is said to emanate from them is considered especially efficacious, and pilgrims come from far and wide to partake of their grace, especially when they are uncovered as on such occasions.

The Imambaras of Lucknow

The sheer size, expense and magnitude of the *imambaras* I visited in Lucknow sit in stark contrast to many of the other religious buildings in the city, including mosques, despite the *imambara*'s limited use during the year. The *imambaras* themselves tend to follow similar architectural layouts and have much in common except for differences in their size. Most of the *imambaras* are approached through large gates and are built with limestone or similar material. Each of the *imambaras* also contains a basin or is located close to a river, so that the *ta'ziya* can be ritually disposed of at the end of the Muharram procession. The *imambara* complexes also encompass separate mosques located to the side of their grounds that are used all year around.

Imambaras are usually rectangular in plan with a vaulted central room surrounded by

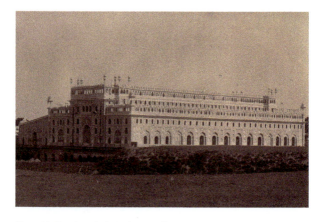

Figure 23. Bara Imambara, Lucknow, India

Built in 1784, the Bara Imambara attracts visitors for the *bhul bhuliya*, or labyrinth, that sits prominently above the main hall and is formed by the numerous balconies and passages that branch off from identical doorways. The monumental structure, as signified in its name 'bara', meaning 'large', continues to serve local congregants and significant mourning rituals during Muharram.

smaller rooms and an ambulatory or veranda. The main room plays host to *alam*s, *ta'ziya*s and *tabut*s, usually in niches or along the perimeter, which are on permanent display or used in the yearly Muharram processions. Many of the *imambara*s also contain the tomb of a patron within the central hall or its grounds. These rooms are usually separated from the other halls by curtains and are dimly lit. The surroundings serve the purpose of accommodating the over-flow of congregants who do not fit in the main hall, or royal observers, as well as displaying the larger *ta'ziya*s that are to be used in the

processions. While Shi'i congregants form the majority of those in the *imambara,* both Sunnis and Hindus also participate in the rituals held each year during the first and second months of the Islamic calendar, Muharram and Safar. Given the shared customs and traditions in paying respect to the deceased, it is not uncommon for Hindus – who form the vast majority of India's population – to attend the *imamabara*s of Lucknow and their sister spaces, the Hyderabadi *ashurkhana*s.

The Ashurkhanas of Hyderabad

In contrast to the monumental *imambara*s of Lucknow, the Hyderabadi *ashurkhana*s are significantly smaller and located off side roads and lesser-known streets in clusters throughout the city. On a day-to-day basis, visitors will come to the *ashurkhana*s to pray, ask for a blessing or make an offering to fulfil a vow (*manat*). Although Hyderabad has a sizeable Shi'i population (the second largest in the country after Lucknow), it is a minority community compared to the Sunni Muslims and Hindus in the city.

Many of the *ashurkhana*s, some equally referred to as *dargah*s, include the body of a sheikh *(shaykh)* or deceased *mutawalli*, a descendent of the religious figure to whom the space is dedicated who was entrusted with the *ashurkhana*. As spaces of Shi'i mourning, *ashurkhana*s are associated with the death of the Prophet's grandson and his family, and contain *alam*s which are believed to have originated

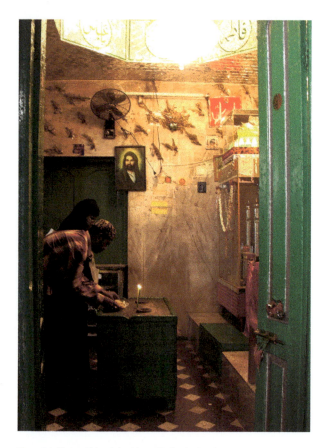

Figure 24. Hazrat Abbas Ashurkhana, Hyderabad, India

A couple pictured visiting this Hyderbadi *ashurkhana* while preparing food as an offering to make a vow. The *ashurkhana* is located on a labyrinthine alley and contains a number of relics associated with its namesake, the half-brother of Imam Husayn.

from the Karbala battlefield. In particular, many *ashurkhana*s are dedicated to a member of the *panj tan* or to Abbas (d. 680), Husayn's half-brother who was also a key protagonist in the historical narrative of Karbala.

A Hyderabadi *majlis* (here, a mourning gathering) that takes place in an *ashurkhana* is typically comprised of a *salam* (introductory poem), *marsiya* (elegiac poem dedicated to Imam Husayn), *hadith* (sermon) and *nawha* (elegy or lamentation). During the course of a *nawha*, the *alam*s may be removed from their respective *alawa* (stand) and carried by young children in an orderly manner around the *ashurkhana*, so that the elderly may also get a chance to receive their blessing. After it has circulated through the gathering, the *alam* is covered with a white cloth and symbolically laid to rest, followed by a *ziyarat-e warisa*, an intercessionary prayer for the deceased. As in most *ashurkhana*s, there are steady streams of women and children who come to catch glimpses or partake in the *baraka* of the *alam*s.

One of the most distinct aspects of the *majlis* is the *matam*, a physical expression of the sorrow of believers for the death of Imam Husayn. Performed during the recitation of the *nawha*, the *matam* can involve a silent rhythmic tap of the chest to keep beat with the recitation, as we similarly saw with the *sineh-zani* practice in Iranian *husayniyya*s. In these South Asian spaces, however, we also observe the practice of self-flagellation with steel chains and swords. As a

fairly modern phenomenon, introduced in the 19th century, some Shi'i Muslims consider this form of *matam* an essential act of mourning, while other communities have distanced themselves from it. In Hyderabadi *ashurkhana*s, the *matam* ceremony is one of the few aspects of the ritual that only Shi'is tend to participate in, while Sunnis and Hindus in attendance act as observers in this part of the *majlis*, especially if the *matam* is very pronounced.

The *ashurkhana* can be an intimate space, both in its size and in the rituals it houses. One such example is the Hazrat Abbas Ashurkhana located inside a labyrinthine alley in the outdoor shopping district of Divan Devri. It is significantly smaller than other *ashurkhana*s in the region and has a reddish-yellow interior with an image of Ali as one enters the inner sanctum. The *ashurkhana* is managed by a female *mutawallia*, Sayyida Takiya Mussavi, and has been in her family for more than 10 generations. As the oldest of seven daughters, Sayyida Takiya Mussavi inherited the role from her late father. During my visit to this space, I witnessed a ritual that involved the offering of food for the purpose of *manat,* or fulfilling a vow. Food was placed on a stand in front of the worshippers while they prayed that their wish be granted. They each took a small bite of the food and left the rest there for the family of the *mutawallia*. I was invited to partake of some of the food, referred to as *tabarruk* for its blessed nature, so I could also share in its spiritual efficacy now that it had been in the

proximity of the *alam*s. This is a common prac-
tice within visits to such spaces, where devotees
vow to make some kind of offering, be it money
or food, in return for the blessings that are associ-
ated with the relics or saints associated with the
space. In some *ashurkhana*s in the region, the
choice of name may even come from these *tabar-
ruk*s themselves, which the *ashurkhana* houses.
Not far from the Divan Devri market we find
Nal-e Mubarak Ashurkhana – the *nal* referring to
the footprint of Imam Husayn which is said to be
held in this *ashurkhana*.

The Ismailis and the *Jamatkhana*

The Ismailis form the world's second largest
Shi'i community. They came to prominence in
the early 10th century, when al-Mahdi (909–934)
proclaimed himself the first Fatimid Imam-caliph.
The Fatimids (909–1171) ruled across North
Africa and the southern Mediterranean, founding
Cairo as their new capital. Theirs was the longest
sustained Shi'i empire, accepting of other faiths,
and where intellectual and cultural endeavours
flourished.

As Fatimid rule began to decline, a succession
dispute led to a schism among the Ismailis. As
a result, the Ismailis split into two branches which
became known as the Musta'lis and the Nizaris.
The Musta'lis continued to rule the Fatimid state
but later established their strongholds in Yemen
and the Indian subcontinent, where proselytizing
activities have kept the community alive until
today. The Nizari Ismailis, on the other hand,

Figure 25. The Ismaili Centre, Toronto, Canada

One of the most remarkable features of the centre is the corbelled glass ceiling that covers the prayer hall, allowing for natural skylight to filter through. The structure was designed by Indian architect Charles Correa (d. 2015), a champion of contemporary sustainable design who is best known for low-income housing and urban planning in Mumbai.

found their most committed supporters in Iran and Syria, where they established a state and a network of mountain fortresses centred at Alamut. They are the only Imami Shia community who claim to maintain a continuous line of living hereditary Imams since the demise of the Prophet.

Prince Shah Karim al-Husseini Aga Khan is the present, 49th hereditary Imam of the Nizari Ismaili community. He succeeded his grandfather in 1957 and now commands the spiritual allegiance (*bay'a*) of millions of Ismailis around the world, across more than 25 countries, with a notable presence in the Middle East, South and Central Asia, Sub-Saharan Africa, North America and Europe. In 2015 the seat of the Ismaili imamate was established – significantly, in a non-Muslim state – in Lisbon, Portugal. Although this is not a political office, the present Ismaili Imam frequently engages diplomatically with global agencies and heads of state, and as part of his mandate he has created various institutions aimed at improving the quality of human life.

The continuity of spiritual leadership has resulted in several key differences between the Ismailis and other Shi'i communities. The unifying voice of the Imam at the apex of this culturally diverse community has engendered an interpretation of Islam that speaks to contemporary life, its changing challenges and realities. Maintaining a historic adherence to the Ja'fari *madhhab*, while also adhering to Sufi principles of personal quest, the Ismailis seek a balance

between external acts of faith (*zahir*) and their inner spiritual meaning (*batin*).

Since at least the early 19th century, as supported by architectural evidence, and possibly earlier, and alluded to in the devotional poetry they recite, Ismailis have prayed in spaces known as *jamatkhana*s. The exact origins of the use of the term *jamatkhana* in the Ismaili tradition are not clear. However, by the mid-19th century, the *jamatkhana*, literally meaning 'house of the community', firmly established its presence as a space of communal gathering and practice in its own right. Many of the earliest examples of the *jamatkhana* may be traced to the South Asian region at this time, with numerous structures found in present-day India and Pakistan. In this primary space of communal gathering, men and women are seated in distinct but adjacent areas, and actively partake in religious activities, including the central ritual that is performed daily in the *jamatkhana*, the *du'a*.

The *du'a* consists of six sections outlining the key, Qur'an-inspired elements of their faith, from recognition of God and the importance of prophethood and imamate, to stressing the importance of allegiance to a living spiritual guide. The *du'a* is also accompanied by sung recitations of devotional poetry in local languages of the congregation, Gujarati, Persian or Arabic, depending on their heritage. These are known by the genre to which they belong: *maddoh*s (praise poetry), *nashid*s (devotional songs), *qasida*s and *ginan*s (devotional poems). They

extol the attributes and teachings of God, the prophets and the Imams, and regale listeners with stories of the lives and instructions of the *pir*s and *da'i*s who are foundational figures in the Ismaili tradition. These are also accompanied by *farman*s, addresses of the current Imam, given within a private context to Ismailis.

The sheer diversity in architectural form and organization of the *jamatkhana* seems to suggest that these spaces emerged according to local factors, be it the economic nature of a community and its resources, or cultural and architectural norms. Therefore, while the *jamatkhana* first appeared as a congregational space for the Nizari Ismaili community, it developed to accommodate the varied Ismaili communities across the world. As a result, the decades of the late-20th and early 21st centuries have seen the emergence of ambassadorial spaces known as Ismaili Centres. Functioning as a *jamatkhana,* and also as a communal hub, these centres can be found in London, Lisbon, Vancouver, Dubai, Dushanbe and Toronto, each being architecturally distinctive and in keeping with its cultural context. In the case of Canada, more than 50 *jamatkhana*s have been built since the late 20th century, many of which have been designed to respond to the needs of the local Ismaili communities who were first welcomed by Canada in the 1970s, having previously emigrated from India to East Africa. The establishment of the Ismaili Centre in Toronto in 2014 marked Canada's second internationally recognized centre (the first being in Vancouver,

opened in 1985). It can be understood as a symbol of generational change, cataloguing the journey of Canada's Ismaili Muslims from a young immigrant settlement to a thriving and well-established community rooted in their distinctive Muslim heritage. Designed by the Indian architect Charles Correa, the Ismaili Centre in Toronto was constructed adjacent to the Aga Khan Museum, which, in turn, was designed by Japanese architect Fumihiko Maki, with a park connecting both structures. The choice of world renowned architects for these centres positions them as cultural monuments that not only cater to the needs of Ismailis but also foster cross-cultural dialogue and engagement. As the Centres continue to serve as spaces of worship, we are able to map how the *jamatkhana* has developed institutionally as a vehicle that serves the burgeoning and evolving needs of this community's social existence.

Chapter 4

Sufi Sites of Devotion

Sufi *Tariqas*

Commonly designated as 'Islamic mysticism', Sufism refers to the practice of striving for communion with the Divine – and thus the truth, love and knowledge of God – via an inward, or esoteric, path. Sufism exists beyond the categories of Sunni and Shi'i groups. Rather, Sufism may best be described as an orientation, for it crosses theological divides. There are examples of Sufis who are Sunni, or Shi'i, and those who transcend these boundaries.

Within the Sufi tradition, *tariqas*, or paths, can act as categories of authority, organization and practice to differentiate groups practising Sufism. A *tariqa* connects together, across time and space, those adherents who subscribe to a particular spiritual master, creating a sense of community through a spiritual family.

Each *tariqa* is usually named after one of its earliest and most efficacious spiritual masters or after the person who is the group's attributed founder. The Naqshbandi *tariqa*, the world's largest Sufi order, is named after the 14th-century Central Asian mystic Baha al-Din Naqshband (d. 1389); the Tijaniyya, Africa's dominant

tariqa, after the 18th-century Moroccan Sheikh Ahmed Tijani (d. 1815); and one of Shi'ism's largest mystical communities, the Ni'matullahi, are named after Shah Ni'matullah Wali (d. 1431).

Every *tariqa* is defined by its lineage of spiritual masters. The term *silsila,* literally meaning 'chain', is used to denote the spiritual genealogy linking back to the Prophet Muhammad that each *tariqa* claims. It is through this verifiable chain that the spiritual mysteries and teachings of a *tariqa* are inherited and legitimized. Almost all Sufi orders, with the exception of the Naqshbandi, claim initial descent from the Prophet through Ali b. Ali Talib. As the first Imam in Shi'i Islam and the fourth of the Rightly Guided Caliphs, Sufis acknowledge Ali as the gateway to the knowledge and light of the Prophet, as is supported by the *hadith* of the Prophet which states: 'I am the city of knowledge and Ali is its gate'. Similarly, Ja'far al-Sadiq (702–765), the renowned Shi'i Imam and influential figure in Sunni jurisprudence, is held in particular regard in the Sufi tradition. There are numerous accounts of his encounters with some of the earliest Sufis and of his knowledge and understanding of the esoteric path. It is through these significant descendants – and their lives and teachings – that Sufis uphold and demonstrate their love for the Prophet. Providing legitimacy, this anchored Sufism's identity to Islam's most exemplary individual, Muhammad. The Prophet's life also manifested a series of other-worldly experiences to which many mystics aspired: be they his night spiritual journey (*isra*) and

ascension (*mi'raj*), or the occasions of revelation itself in which God spoke directly to His creation. Therefore, it is unsurprising that the Sufis' love for the Prophet manifests in a very tangible way – and that this is exhibited through a number of their practices.

As well as the particular nature of its spiritual authority, a *tariqa* is also shaped by its rituals and practices. In addition to the daily *salat*, there are often other practices of a personal and communal nature that are prescribed by the *shaykh*, or spiritual master, as part of the *tariqa's* tradition. This usually involves a spiritual concert often known as a *sama* (listening) or *hadra* (indicating the presence of the Divine). The form of these can be vastly different, but the common goal is the same – to bring one into proximity with God and to participate in the feelings of intimacy, ecstasy and spiritual satisfaction that may come with that.

Furthermore, there is the rhythmic recitation and prolonged repetition of God's names or attributes known as *dhikr*. *Dhikr* is a spiritual exercise through whose regular practice the mystic's heart becomes polished so that God's presence can be felt and His grace experienced through its mirror. Each *tariqa* may have certain formulas to which they ascribe particular efficacy or which over the years have become embedded within their practices. Sometimes these are paired with movement. The most visible example of this is with the Mevlevi (or Mawlawiya) *tariqa*, also known in European and North American

circles as the 'Whirling Dervishes', named after
the great Sufi poet and mystic Jalal al-Din Rumi
(d. 1273), or 'Mawlana' (Mevlevi in Turkish)
meaning 'our master'. Other *tariqa*s practise what
is often referred to in the literature as silent *dhikr*,
which takes place quietly within the heart.

Tracing Sufi Spaces of Worship

The early centuries of the development of Sufism
are marked by charismatic individuals who domi-
nated the discourse of the mystic arts through their
teachings and writings, often in the form of poetry.
These include Dhu'l-Nun al-Misri (d. 859), Hasan
al-Basri (d. 728), Sahl al-Tustari (d. 896) and the
female mystic Rabi'a al-Adawiya (d. 801), who
is often regarded as a saint. As the reputation of
these teachers and others became known, students
flocked to them in the hope of being taken under
their tutelage. This master–disciple (*pir–murid*)
relationship became the hallmark of Sufi teaching
and allowed each teacher to pass on to their
students the spiritual discipline and tradition
associated with their practice. In time, this quest
for knowledge – as was encouraged in Islam at
large – led to the emergence of residential institu-
tions which could house the various itinerants
who would travel from one knowledge centre to
another to spend time in the company of a sheikh.

Institutions associated with Sufi practice
often resemble residential structures; the most
common examples are the *khanaqah*, the *zawiya*,
and the *tekke* (or *takiya*). While having overlap-
ping functions, these institutions are distinct not

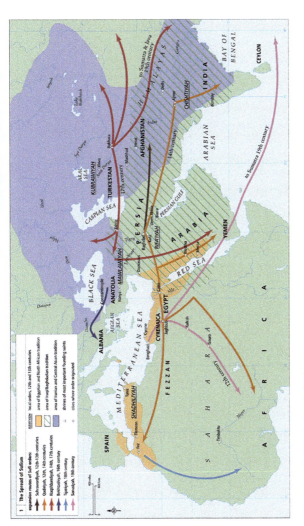

Figure 26. The Rise and Spread of Sufism

A map highlighting the geographical diversity of Sufi orders, spanning from Central Asia to North Africa. Many *tariqas* spread via popular trade routes where institutions, shrines and places of gathering were established for wayfaring mystics on their quests for knowledge.

only in terms of different communities they may
serve, but also in their geographic reach and
dispersion, and to some extent in the linguistic
communities they emerged from. Today, these
names are used somewhat interchangeably and
added to them are designations used more
distinctly by specific communities or regions.
For others, the mosque or mosque-like spaces
remain the site of practice for Sufis. In addition
to communal spaces, a range of spaces devoted to
solitary practice have also emerged.

The *Khanaqah*

One of the first Sufi spaces of worship to gain
widespread appeal was the *khanaqah*, a Persian
term that literally means 'the place of the house'.
It suggests that the earliest of these structures
emerged from the hospitality and generosity of
the sheikh's home and his ability to temporarily
house students.

Around the 10th and 11th centuries, the
khanaqah seemed to become a more formalized
space in present-day Iran which also spread
to other parts of the Muslim world, including
Egypt. As Sufism moved from the margins to
more generally accepted practice, it gained the
patronage of rulers across the Muslim world –
kings, caliphs and sultans alike. This favour
resulted in the development of purpose-built
and regal *khanaqah*s, primarily in caliphal capit-
als alongside the more informal structures that
had already begun to develop. In Arab lands, the
khanaqah continued to serve the purpose of a

residential centre for students and visitors on the mystic path.

In later iterations, the focus of the *khanaqah* was transformed and it began to include areas demarcated for ritual functions. This included spaces for devotional practices, such as *dhikr* and *sama,* as well as for the recitation of, and listening to, poetry and music specific to particular Sufi traditions. Some Sufi teachers and sheikhs were buried in their *khanaqahs*, transforming these places into pilgrimage sites. Like all sites, the social life of the institution developed over time to meet the changing needs of the peoples and cultures that it served.

The residential aspect of the *khanaqah* increasingly became less important in light of its ritual functions. And many of the *khanaqahs* of more modern provenance act mainly as a ritual, social and educational space for a *tariqa*'s activities.

The *Zawiya*

The *zawiya* developed alongside the *khanaqah*. The term comes from the Arabic meaning 'corner', 'a small room' or 'assembly' and has been used to denote slightly nuanced institutions even within the same regions of the Muslim world. Before the colonial era, the *zawiya* functioned as a *madrasa* in North Africa, or the Maghrib, and West Africa. Its primary purpose was the teaching of Arabic reading and writing, engaging in grammar, theology, maths and astronomy. Its presence as such can still be felt in certain African regions, from Nigeria to Sudan.

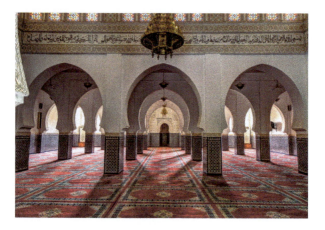

Figure 27. Moulay Ali Sharif Zawiya, Rissani, Morocco

This quaint *zawiya* in the south-east of Morocco houses the tomb of Moulay Ali
Sharif (d. 1659), the founder of the Alawite dynasty of Morocco. The view here
captures the harmonious interior of the prayer hall and its numerous arches
that lead the onlooker to the central *mihrab*.

However, aligned more closely to the
khanaqah or *takiya*, the *zawiya* also held signi-
ficance as a Sufi lodge. As charismatic individuals
who became associated with the mystical path
settled in various areas where Muslims lived,
*zawiya*s also developed and were often centred
around the tombs of those who were believed to
have communicated *baraka*, or spiritual grace,
in their lifetimes. These shrines are found dotted
through cities, towns and villages in North and
West Africa and visiting them is an important
aspect of piety for many of the region's Muslims.
While individual *zawiya*s may function some-
what differently from each other, the buildings

are as prominent (in some cases more so) than mosques in particular regions of a country, especially in the less populated terrains punctuated by mountains, deserts and coastlines. In a number of environments, they also function as *masjid*s and are used by the local populace as well as organized mystical fraternities. A *zawiya*, like a mosque, has no fixed structural template and can be of different sizes and grandeur. In less urban environments, the *zawiya* can often incorporate white facades and domes, whereas larger *zawiya*s have scope to be more elaborate, providing integral space for the devotions of Sufi communities.

The *Tekke* and *Takiya*

The *tekke* developed around the 16th century in Ottoman controlled lands and became the space used by mystical fraternities for their own practices. Often used interchangeably with the term '*zawiya*', the *tekke* has been translated as a dervish lodge, with specific quarters allocated for ritual practices of the community as well as living space in the case of particular fraternities. The presence of the *tekke* as a designated space for ascetics coincided with the wider controlled, organized and more standardized approach to mystical spaces of worship in Ottoman lands. In the Arabic speaking world, similar spaces are often known as *takiya*s and in Iran as *takiyeh*s. The linguistic roots of all these terms allude to a sense of support or holding up, as well conveying the idea of a chamber where one rests while

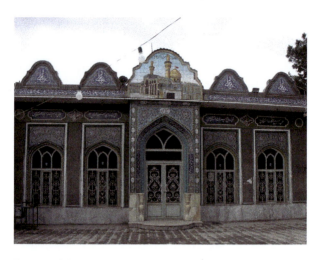

Figure 28. Khaksari Takiyeh, Kermanshah, Iran

Situated in the western Iranian province of Kermanshah, this *takiya* is home to the Khaksar Sufi order, a Shi'i-oriented order that traces its spiritual masters to the 13th century. The Khaksari Takiyeh features stylized crenellations that reveal the names of Imam Husayn and the Prophet Muhammad, while the central panel includes a depiction of Imam Husayn's shrine in Karbala.

being sustained with food and drink. Thus, the *tekke,* or *takiya*, can be understood as a place where one rests or makes a retreat.

As an institution, the *tekke* can be considered as an umbrella term that included the spaces of particular groups. For example, the distinctive ritual performances of the whirling dervishes, or Mevlevis as they are more formally known, take place in spaces known as *mevlevihanes* (literally, Mevlevi lodges) in Turkish-speaking lands. In fact, having found fruition within an Ottoman context, the *tekke* is to some extent intrinsically

attached to a non-Arab identity, with some accounts claiming that *tekke*s in Cairo existed for specifically Turkish and Persian Sufis.

During my journey and interactions with mystically inclined communities in Senegal, Iran and Turkey, the *khanaqah, zawiya* and *tekke* came to life as examples of spaces where space and ritual intersect for the worldwide Sufi community.

Senegal's Tijani Order

In Senegal, continental Africa's westernmost country, the majority of its approximately 15 million citizens are Muslim, many of whom are attached to one of several Sufi *tariqa*s within the country. Tenets and institutions of Sufism in Senegal feature in a public way. Amidst the Sandaga market, located in Senegal's capital, Dakar, it is commonplace to hear the reverbera-tions of the voices of men in small circles singing the praises of God and the Prophet, as prayer and *dhikr* circles form part of every-day life both at home and in neighbourhood squares. Similarly, images of sheikhs in the form of respectful drawings can be seen on every domestic and retail wall or facade and are worn by adherents on clothing, necklaces, and talismans.

Of the numerous Sufi *tariqa*s, the Sunni Tijanis comprise the largest of the orders in Senegal and all of West Africa. The Tijani order is relatively recent in the history of Islam in West Africa. Founded by Sheikh Ahmed Tijani, the *tariqa*, which can be traced to the end of the

18th century, quickly spread throughout the Muslim world, particularly West Africa.

Sheikh Ahmed Tijani is seen as an inheritor of the Prophet's legacy and one who has shared communion with him. One of the results of this relationship was the emergence and institution of a system of prayers which it is claimed the Prophet revealed directly, without an intermediary, to Sheikh Ahmed Tijani in a waking dream. Just as a long cycle of previous prophets culminated in the Prophet Muhammad, Ahmed Tijani is seen as the last and most perfect of a series of spiritual leaders known as *qutbs* (literally, an 'axis', or 'pole') whose role it was to share the Prophet's legacy in the contemporary world as the appointed channel of God's grace.

As in all Sufi orders, adherents of the Tijani order attach themselves to a *muqaddam* (a representative of the order) or *marabout* (the term collectively applied to personal teachers or sheikhs as part of the mystic path). Affiliation is formally expressed through a ceremony in which the *wird,* or litany, is formally conferred and the recipient accepts the conditions of joining the *tariqa.* However, in practice, one is considered a Tijani member by virtue of his birth into a practising Tijani family.

Aside from the religious obligations incumbent upon all Muslims, the Tijani order is distinguished by three additional prayer practices: the *wird*, *wazifa* and *hadra.* All three prayers are grounded in the remembrance of God and specifically His 'oneness' (*tawhid*), as

well as the seeking of forgiveness and redemption. The *wird* is performed twice daily and considered the first set of prayers received from the Prophet Muhammad that Sheikh Ahmed Tijani was instructed to transmit to adherents. While the *wazifa* can be performed at least once a day and often takes place in a group within the mosque or *zawiya,* similarly, the *hadra* (or *dhikr*) takes place communally on a Friday following the afternoon prayer and *wazifa.*

In the Senegalese context, the *masjid* and the *zawiya* are the primary sites of piety for Muslims. While both terms are commonly used interchangeably in Senegal, the *zawiya* is most correctly applied to mosques that encompass shrines within their premises, or mosques which a sheikh of one of the *tariqa*s uses as a teaching site.

In addition to the *salat*, the mosque or *zawiya* is often the site of special liturgies and prayers for the Tijani *tariqa*. Since Sheikh Ahmad Tijani's *zawiya*, the mother *zawiya* of the community, is in the Moroccan city of Fez, a number of Tijani branches have their own *zawiya*s, such as those in the towns of Tivaouane and Kaolack in Senegal. In addition to providing sites for communal prayer, each of these *zawiya*s is also a focal point of pilgrimage during the annual festivals. On Fridays and special occasions, men dress up in their finest traditional robes sporting bright colours and bold designs, known as *boubou*s. During this time, the *zawiya*s are replete with pilgrims, both men and women, who come to

perform the various pilgrimage rites and seek guidance and blessings from their *marabouts*.

While some mosques have designated areas for women, it is usually men who can be seen within these spaces. *Zawiyas*, on the other hand, welcome both sexes. In fact, women are active participants in the context of Islam in Senegal, and it is the Tijani order in particular that has encouraged their presence. A key leader of the order in the 20th century, Sheikh al-Islam Ibrahim Niass (d. 1975), implemented the notion that women could in fact reach the status of a *muqaddam* and thus form an integral part of the Tijani community as spiritual guides with the authority to initiate

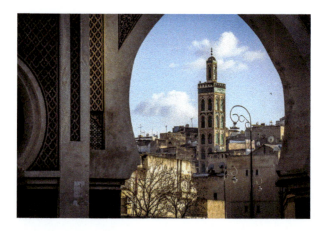

Figure 29. Sidi Ahmed al-Tijani Zawiya, Fez, Morocco

This prominent minaret found in the heart of the old city quarter of Fez belongs to one of many *zawiya*s devoted to the founder of the Tijani order, Sheikh Ahmed Tijani. It is distinguished, however, as the burial site of the Sheikh himself who initiated the site's construction before his death in 1815.

others into the order. This arguably paved the way for women, such as his daughter Seyda Rokhaya Ibrahima Niass (b. 1930), to become notable religious leaders and scholars of the Tijani order. While the presence of women as *muqaddama*s remains somewhat unknown to the outside world, their significance within the communities of Dakar is firmly established.

Today, the spiritual leadership of the order lies with Sheikh Ahmad Tijani Ali Cisse (b. 1955), brother of the late Sheikh Hassan Cisse (d. 2008), who remains a popular and influential figure in the Tijani community. Educated in Cairo and London, Sheikh Hassan Cisse was known to have attracted a worldwide following that has encouraged the spread of the Tijani order in places such as the United States, where he founded the African American Islamic Institute in 1988, with the aim of promoting education and development. It is thanks to such efforts, which have in turn encouraged interfaith dialogue across regions, that the Tijani community is a vibrant and diverse community with an increasing following in Europe and America, all the while remaining present in the West African region where the leader of their community resides.

Iran's Ni'matullahi Order

The Ni'matullahi *tariqa*, named after its founder Shah Ni'matullah Wali (d. 1431), is one of the largest mystically oriented Shi'i orders in Iran. Their weekly meetings are full to capacity even though they have some of the largest

congregational Sufi spaces in the country. Similar to the Tijanis of Senegal, the head of the community is known as the *qutb,* who guides the affairs of the community and through whom the grace of the Divine is made both known and accessible to the world. The Ni'matullahis believe that the *qutb* is appointed or authorized by the Imam for spiritual guidance and education. While the Imam's perfection is like the sun whose light comes from himself, the perfection of the *qutb* is like the moon whose light comes from the sun – he is the Imam's deputy. In this spirit, on

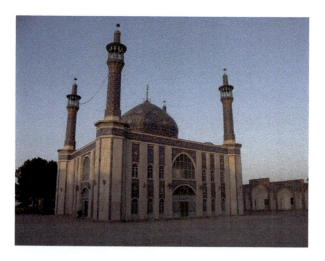

Figure 30. Ni'matullahi Gonabadiye Shrine and Khanaqah, Gonabad, Iran
The Mazar-e Sultani shrine is an important and active site for the Ni'matullahi community in Bidokht, Gonabad. The large complex contains the tomb of a previous *qutb* of the community, Sultan Ali Shah-e Gonabadi, a library, and a *husayniyya.*

Thursdays he holds meetings at his house to talk to his followers. Anyone is allowed to attend these meetings, to listen and speak with him.

The Ni'matullahis hold prayer gatherings each week in several spaces: namely *khanaqah*s, or *husayniyyas*. While these spaces are traditionally known as *khanaqahs*, today they are more commonly referred to as *husayniyyas* – a term readily associated with general Shi'i spaces of worship and therefore less problematic to the state. In past decades, due to the rising popularity of mystical movements like the Ni'mutallahi and more vocal anti-government voices, there have been attacks on their spaces of worship as well as arrests of senior members of the order.

The Ni'matullahis make a distinction between those individuals who come to the communal gatherings and practice but are not initiated – *talib*s, or seekers – and those who have gone through the initiatory ritual of *dast-giri* (hand-giving), referred to as *murids*, or disciples. A *talib* can ask permission of the *qutb* or an authorized sheikh to join the *tariqa*. The ceremony itself takes place one-on-one in a small room designated for the purpose of *dast-giri*. Here commitment and vows are made to the *qutb* by the initiate and water is sprinkled onto his or her face. While there are many women in the order who are spiritually advanced and who actively participate in the ceremony of *dast-giri*, they are not able to rise to the position of sheikh, and thus remain outside the realm of ritual practitioners in the Ni'matullahi *tariqa*.

One of the most important Ni'mutallahi *husayniyya*s is the Amir Sulaymani Husayniyya in Tehran. The Amir Sulaymani Husayniyya is approached through a long and narrow car park and is next to a public day-clinic maintained by the order. Men and women enter through the same outdoor gate but are separated once inside the forecourt and are ushered through separate entrances to the building. In the forecourt, before the entrances is a bookshop selling books of the *tariqa* and, a few metres away, a small kiosk selling a selection of video and audio copies of the present and previous *qutb*s' addresses.

At the Amir Sulaymani Husayniyya, the meetings of the Ni'mutallahis take place on Thursday and Sunday evenings, as well as early Friday mornings after the *fajr* prayer and again a few hours later at a larger venue. During these gatherings, when the appointed sheikh for the Husayniyya enters the building, everyone stands. The sheikh, who is authorized by the *qutb* as a ritual practitioner, takes his place on the ground level of the main hall upon a white cloth. The row of congregants closest to him sits first, after which the second row takes their seat, continuing on until the last row is seated. Shortly after, the *qutb* enters the main hall and sits to the left of the sheikh. Often, elders of the community or relatives of the sheikh will sit in the front row facing the congregation. Upon the *qutb*'s entrance, many of the community will reposition themselves, with the raised sections on either side of the room enabling people to catch a glimpse of their master.

Sitting to the extreme left of the *qutb* and sheikh and also facing the congregation is a man who sings, first, prose poetry of some of the spiritual forefathers of the mystical tradition in Iran – Rumi, Shams-e Tabriz, Hafiz – followed by more poetry sung in rhyme. Usually, the person reciting sings on his own, but on occasion a congregant whispering under his breath may join in.

On Thursday nights, this is followed by the *qutb* delivering a speech on a topic of his choice. Subsequently, the *qutb* rises along with those sitting with him, including the sheikh, and heads towards the *mihrab* in the centre of the hall to kneel. *Salat* is then performed, merging both the evening *maghrib* and *isha* prayers, as the congregants now too face the central *mihrab*.

After individuals perform the *salat*, some will continue to offer the optional *rak'as* silently and then perform *salam,* or a blessed greeting, to the Imams in three directions: one in the direction of Karbala to Imam Husayn, the second towards Mashhad to Imam Reza (d. 818), and the third towards the *qibla,* dedicated to the awaited 12th Ithna'ashari Imam.

As for the Friday morning sessions, these begin in the early hours at Haheri Husayniyya, a more intimate venue than the expansive Amir Sulaymani Husayniyya. The early morning session usually begins with the recitation of *munajat* (invocation) and on occasion, there is a separate time allotted for congregants to perform their *dhikr-e qalbi,* or silent *dhikr*. This is

followed by the *fajr salat*, and a recitation and commentary of the Qur'an by the *qutb* or, in his absence, the sheikh, followed by breakfast eaten together.

The second session on Friday morning then takes place at Amir Sulaymani Husayniyya to accommodate the much larger congregation. The first part of the ceremony, until the *qutb* and sheikh enter, is identical. Once the *qutb* arrives, an individual takes the microphone to the left of those in the front and recites the *silsilat al-awliya,* or chain of succession of the *tariqa.* Since the chain of authorization is central to this Ni'matullahi *tariqa,* the reading of the *silsila* is key to affirming the order and the *qutb*'s legitimacy.

During the later recitation of *qasida*s (devotional poetry), a voluntary line, sometimes up to 100 people, begins to form to the left of the main hall. With his permission, one by one, the male congregants are seen by the *qutb.* Dervishes, or initiated members, kiss the *qutb*'s hand while he kisses theirs in the particular style used by the *tariqa.* At times words are exchanged between the two and sometimes a letter is even offered to the *qutb*, which he may read and respond to right away or later.

Once he has seen the interested parties and the *qasida* recitation is complete, the *qutb* rises and goes to attend to the women congregants who are present in a separate area of the *husayniyya* throughout the session. All the while, the *qutb* remains central to both the

space and the rituals that the Ni'matullahis perform.

Turkey's Mevlevi Order

While Senegal's Tijani and Iran's Ni'matullahi communities offer windows into the practice of Sufism and its relationship with space through the *zawiya* and *husayniyya* respectively, Turkey's Mevlevi *tariqa* (or *tarikat* in Turkish) provides a different model of Sufism, where sacred dance, movement and classical modes of music are integral parts of the spiritual experience. Sufi orders in Turkey also have a different and complex relationship to the nation-state. Until the late 19th century, Turkey's modern history saw Ottoman reforms that strived for the central-ization of such orders, which ultimately resulted in their official abolishment and the subsequent emergence of numerous underground networks that allowed the tradition to survive. Today, while Sufism remains somewhat isolated from the state, ironically Turkey is celebrated world-wide as the social and cultural centre of Sufism – without it, Turkey's tourism industry would be incomplete. Thus, Sufi *tariqa*s, still challenged by external forces, express their practice in covert ways, often existing as social and cultural phenomena, as opposed to formalized religious expression.

The most famous of these enduring communit-ies is the Mevlevi order, or Whirling Dervishes, founded by the followers of the 13th century poet and Sufi mystic, Rumi. The profound and

Figure 31. Mevlevi Whirling Dervishes, Istanbul, Turkey

In the Galata Mevlevihane in Istanbul, *semazens* or 'whirlers' of the Mevlevi order engage in the whirling prayer ceremony in front of a crowd of tourists. This particular *mevlevihane* operated as a site for religious activities until 1925 when it was closed down during the Turkish constitutional reforms. It reopened as a school – and later a museum – in 1975 and has welcomed tourists ever since.

universal message of Rumi's poetry continues to inspire people of all denominations, with his *Diwan* or *Mathnawi* now inscribed in the popular consciousness through many editions and translations. Consequently, a great many visitors are drawn to Turkey to visit Rumi's shrine complex in Konya and witness for themselves the numinous spectacle of the Whirling Dervishes. The Mevlevi dance of devotion is one of the most serene, unique modes of Muslim prayer, where the heart and mind must transcend matter, and prayer is found in the quiet centre of one's heart despite the dizzying orbit of the body which contains it.

The whirling prayer ceremony, known as the Mevlevi *sema* (*sama* in Arabic), is performed in the *semahane*s of the *tekke* complexes. Every *sema* chamber contains a platform reserved for visitors and divided between men and women. Either circular in shape or octagonal, the hall is used by those who whirl in the company of the musicians and singers. Although the *sema* was performed only in Mevlevi lodges in the past, it has now become a common mystical ritual which has the potential to be performed in any place, provided that it is agreeable to Mevlevi ethical concerns. While this is often performed in the guise of tourist ceremonies, the ritual remains grounded in the significant mystical experience for those participating.

All *ayin*s, or customary rituals, begin with the *salawat*, or blessings and salutations, offered for the Prophet as an expression of love and

veneration for him. Such expression is carried out in the Mevlevi *ayin* by means of hymns or by chanting of litanies, known as the *Nat-i Mevlana*. During the recitation of the *nat*, there is complete silence. However, once the recitation is over, the *küdüm* (double drum) is struck, followed by an instrumental improvisation on the *ney* (flute). The head double-drum player gives a signal by hitting the drum once for the commencement of the *peşrev* (interlude). At this moment, the sheikh and *sema* performers (*semazen*) strike the floor forcefully with their hands and stand up at once.

In the following part of the ceremony, the sheikh and the *sema* performers make three circles around the *semahane*, while the musicians continue to play. If the *peşrev* ends before the completion of the tour, they start playing all over again.

The next part of the ceremony consists of the 'four *salams*'. The singers on the platform begin to sing the *ayin*. All the *semazen*s take off their cloaks and take the appropriate position for the *sema* and prepare to perform the ritual whirling. The dervishes let their hands down slowly from their shoulders and raise them upward with their right palm facing up, their left palm down. The *semazen* also bends his head slightly down on the right side and turns his face slightly to the left while narrowing his eyes and looking at the thumb of his left hand. It is in this posture that they whirl. The *semazen*, in his every rotation, recites in his heart the name of Allah.

The ending of the first *salam* of the *ayin* and the beginning of its second *salam* is understood from the change of the rhythmic pattern of the composition. The moment the *semazen*s discern this change, they stop with their faces turned towards the centre of the *sema* hall, called the Kütüphane (library), and salute in the appropriate posture and lean against one another, shoulder to shoulder, within groups of either two or three. The sheikh reads the supplication pertinent to the *salam* in question and moves back and takes his place behind the *post*, the ceremonial mat on which he sits. All of the *semazen*s perform the salutation once again and proceed to perform the *sema*. The second *salam* continues in the same way, and again with a change in the rhythmic pattern in the composition, the *semazen*s enter the third *salam*. The same procedure is also repeated during the entry into the fourth *salam*.

As soon as the vocal part of the *ayin* of the fourth *salam* is over, the musicians begin to play the last *peşrev*. This is followed by the litany (*illahi*), which is concluded with another instrumental improvisation. During this last improvisation, the sheikh who retains his fixed position in the centre, starts moving back slowly to his *post*. Once he reaches the *post*, the improvisation ends. In the final part of the ceremony, someone – most likely a *hafiz*, who knows the Qur'an by heart – starts reciting a portion from the Qur'an, followed by a silent communal recitation of the opening chapter of the Qur'an, otherwise known as *Surat al-Fatiha*. Despite the

fact that the Mevlevi practice, as with other Sufi rituals, is still largely discouraged, communities continue to exemplify their faith and resilience in practising such rituals on a day-to-day basis, even if outwardly these take the form of displays laid on for tourists.

While we tend to think of Sufism as a singular homogenous tradition of Islam, in reality, it represents multiple ways and approaches to knowing and feeling God's presence, as we have seen. Each Sufi *tariqa* demonstrates a particular orientation and way of engaging with the Divine, so both the proponents and the details of its mystical paths, in theory and practice, vary greatly; so greatly, in fact, that some forms of Sufism are condoned by the religious elite and states while in the same country, other *tariqa*s are not. This is evident with the Mevlevi, Tijani and Ni'matullahi communities, who all offer visions and examples of the mystic path influenced by various historic trajectories, cultural articulations and relationships with the nation-state.

Despite these differences, Sufism's hallmarks include an institution of legitimized authority in the form of a spiritual master and mentorship. This institution encompasses the broader well-being of disciples, ritual acts which invoke and call upon the Divine, and spaces of worship in which those rites take place. Spaces such as the *khanaqah, zawiya, tekke* and others are essential to the history and development of Islam. They are not tangential or marginal to Muslim experience. Rather, in the same way that the

masjid developed in different ways throughout the world – both architecturally and through the rituals that developed and were enacted within its walls – so too did the wide range of Sufi spaces.

Chapter 5

Transcending Boundaries

As I began to encounter various representat-
ives of communities who felt the Sunni-Shi'i
boundaries did not do justice to their experi-
ence of being Muslim, I realized how much
of the Muslim world I had yet to discover. In
almost every country, there were groups who
challenged my understanding of the categories
of Sunni and Shi'i and whose interpretation of
Islam and Islamic law was somewhat different
than those upheld by the vast majority of Shi'i
and Sunni communities.

These groups often have different spaces
of worship, a distinct set of rituals and less focus
on the precepts of Islam that have come to define
both the Sunni and, to a lesser extent, the Shi'i
constituents of Islam. Instead, they emphasize
the inner dimensions of Islamic law, or *shari'a*,
which are referred to in different typologies as
tariqa (the path or way), *haqiqa* (the truth) or
ma'rifa (inner knowledge, or gnosis).

These communities, who interpret the *shari'a*
and religious practice through the lens of *iman*,
or faith, demonstrate an understanding of inner
faith over public piety and the spontaneity of the
spiritual encounter over the fixed regiment of a

formalized practice. They believe that an inward orientation can find outward expression in a variety of ways – not only through the *masjid* and the *salat* but through parallel institutions of worship and different canons and trajectories of religious practice which emerged as Islam came into conversation with a community's local context and environment. I was exposed to this ritual dialogue through a number of communities I came across, including the Zikris of Pakistan's Baluchistan province and the Druzes of the Levant.

The Zikris of Pakistan

Home to 200 million Muslims, Pakistan has teeming within its borders the second largest density of Muslims of any nation, second only to Indonesia, and just ahead of its neighbour, India. Concentrated in southern Baluchistan along the desert highways and coastal contours of Pakistan's Makran coast, the country's Zikri Muslims derive their name from the Arabic word *dhikr* (literally, remembrance). In Karachi, Zikri communities and enclaves tend to be clustered in the city's less-advantaged areas.

As a bounded community, the Zikris' origin seems to be linked to a historical moment in 1496 when one Syed Muhammad Jaunpuri (d. 1505) declared himself as the *mahdi,* or messianic redeemer of Islam. The Zikri belief concerning the *mahdi* is somewhat different from that of Shi'i Muslims, who believe that the *mahdi* will be a figure from the line of their imams. Sunnis also believe that the *mahdi* will

appear at an undesignated time. For the Zikris, the *mahdi*, foretold in the *hadith*s of the Prophet, has come and gone.

In the Zikri understanding of time and history, the *mahdi* made his appearance near the town of Turbat, not far from Pakistan's southwest border with neighbouring Iran. Even the exact site of his appearance is known and commemorated by the Zikris today: a place known as *Kuh-i Murad*, Baluchi for 'Mountain of Wishes'. On 27th Ramadan 1504, only one year before the *mahdi*'s death, two other *sayyid*s, whose descents are traced to the Prophet, Syed Khudodad Chirag and Syed Shah Muhammad Dor Afshan, encountered and heeded the *mahdi*'s proclamation and call. The descendants of these original witnesses continue to lead the community today and are known as *murshid*s, or spiritual guides, referred to by the Zikris as *waja*, a title of respect.

The anniversary of the *mahdi*'s appearance is commemorated every year. On this auspicious day, Zikris make the pilgrimage to central Baluchistan to memorialize the sacred occasion, but also with the hope that the *mahdi* might reappear once again as he did 500 years ago. On the early morning of that day, the Zikris also celebrate *shab-e qadr*, the night of destiny, in which the Prophet Muhammad received his first revelation at the cave of Hira, near Mecca.

The Zikr-Khana

The site of daily Zikri practice is known as the *zikr-khana*, literally the 'house where God's name

is remembered'. It is at this site rather than the mosque that observant Zikris gather three times a day (under increasing pressure, some groups now meet five times), sit in a square formation facing the centre of the room and perform a prayer consisting of Baluchi and Persian formulas, Qur'anic verses and the repetition of God's name through postures of standing, sitting and prostration (*sujud*). This practice is known as *zikr* (used in South Asia as a variant of the Arabic '*dhikr*').

The Zikri rite takes place at *fajr*, *zuhr* and *maghrib*. Congregants wear clean white or light clothing and cover their heads with a *rumal*, a large cloth or handkerchief, washing themselves before attending the ceremony. At the centre of the square formation, an individual who is familiar with the *zikr* ritual leads the prayers. The *salat* or *namaz*, which is the mainstay of many Sunni and Shi'i Muslims, is associated with the mosque, and as such is not part of the liturgical repertoire of the Zikris.

Zikr-khanas usually consist of separate structures for men and women, often next to each other, sharing the same name. Older *zikr-khanas*, however, have separate floors for men and women to practice. All Zikris, young and old, are permitted to attend prayers. However, non-Zikris are strictly forbidden to enter during prayer times.

The buildings themselves take on different forms, and do not seem to have a uniform architectural template; newer buildings tend to

include a minaret. In other *zikr-khana*s, tapestries depicting the Ka'ba can be seen adorning the wall, however, the direction of prayer is focused to the centre of the *zikr-khana* rather than a Mecca-facing *qibla*.

The interior of the *zikr-khana*s I visited all shared an internal quadrilateral plan, and were generally quite modest structures. Within Zikri enclaves there are often many smaller *zikr-khana*s rather than a large single edifice. Their floors were either covered with carpets in some of the older structures or made of marble in the newer buildings. The walls were often decorated with verses of the Zikri liturgy, some of which are drawn from verses of the Qur'an. *Zikr-khana*s are usually built upon *astana*s, which are places deemed sacred or holy by the community. These could include the site of a *waja*'s meditation, or the house of a former leader of the community.

On special occasions, the *chaugan* (the reading and reciting of extracts from pre-modern Baluchi poetry) also takes place. On these occasions, community members stay up all night to participate in various devotions. To help support these occasions, funds are collected from community members so that these events can be organized. They begin with one expert standing in the centre of the *zikr-khana*, who recites a special prayer in Baluchi, with some Arabic vocabulary, until he is tired and is replaced by another officiator. During this ceremony, congregants all stand. While it is not

deemed obligatory to participate in the *chaugan* ritual, it is highly valued amongst the Zikris. The *chaugan* begins after the sunset prayer and can last until dawn; it usually occurs on the night of *shab-e qadr*.

The Druzes

The Druzes first emerged as a discrete group around 1017. Druze theology anchors itself heavily in the teachings of Hellenic philosophers such as Aristotle and Plotinus, as well as Hamza b. Ali (d. 1021), a *da'i* of the time of the Fatimid Imam-caliph al-Hakim (r. 996–1021). In addition, scholars have also noted how elements pronounced in Gnostic, Judaic and Christian worldviews find themselves prominently featuring in the interpretation of Islam that the Druzes practise.

Stemming from the Fatimid Ismaili mission, the Druzes split from the Ismailis primarily because of the way they understood the nature and status of the Ismaili Imam vis-à-vis the Divine Essence. The Druzes continued to function as a proselytizing missionary movement until 1041, when under immense pressure the group decided to go underground. Since that time, conversion into the faith has been prohibited, with few exceptions, an approach that continues to this day. In the three largest Druze communities in Syria, Lebanon and Israel, a head of the community known as the *shaykh al-aql* is elected by the population. He is the highest religious authority within that national jurisdiction.

Other than this, there is no clerical hierarchy in the community and each community has relative autonomy with respect to the others.

One of the defining features of Druze religious life is the division of its membership into two groups: the *uqqal*, or initiated, and the *juhhal* or *jismiyya*, the uninitiated. There are distinct sets of practice for each group, but on particular occasions there is convergence. The *juhhal* participate in many of the rituals of the community, including shrine visitation and the optional attendance on Thursday evenings in the *majlis,* the primary space of Druze prayer. They do not participate in the ceremonies of self-imposed solitude, meditation and retreat, known as *khalwa*, although they are permitted to visit. The *uqqal* also participate in shrine rituals, especially on the death anniversaries of saintly figures, but do so as a group and separately from the *juhhal*, usually keeping vigil and praying from the evening right into the morning. Certain advanced ranks of spiritual leadership, known as sheikhs, spend considerable time in the *khalwa* and all of the sheikhs are required to attend the private ceremonies on Thursday evenings in the *majlis* after the *juhhal* have left. They also spend time as a group in the *majlis* on other days of the week and on special occasions such as Eid al-Fitr and Eid al-Adha.

The foundational text of the Druze faith is known as *Rasa'il al-Hikma* or *The Epistles of Wisdom*. It is a compendium of sacred texts and

pastoral letters by the founders and earliest proponents of the Druze faith. In understanding the *Epistles*, as well as other texts, the Druze believe that there are three ways in which these texts can be accessed. The first is through the *zahir*, that which is apparent and accessible to anyone who can read or hear. The second is the *batin*, the hidden, which is accessible to those willing to search and learn through mentorship and exegesis. The final is the hidden of the hidden, the *batin* of the *batin*. This level of understanding is inaccessible to all but the few enlightened individuals who truly understand the nature of the universe.

In Lebanon, the Druze have three primary spaces that are used by individual community members or a congregation for the purposes of piety and worship. The first of these spaces, the shrine, or *maqam*, understood by the Druze as 'places of divine manifestation or residence', are built in deference to religious figures reputed to have reached high levels of spirituality and to have performed miraculous acts. Next to the shrines in spiritual importance are the various retreats, or *khalwat*, that the very pious visit regularly for worship. These retreats are often found on hilltops outside villages, but may also be located inside homes within villages and towns. The *majlis*, or assembly hall, is the primary communal and ritual space for the Druze community. Like shrines, these spaces are open to both the initiated and the uninitiated, and are found wherever the Druze reside.

Druze Shrines

There is hardly a Druze village that does not have one or more shrines. Druze shrines are often adorned with carpets and multi-coloured pieces of cloth covering the floors, walls and the tomb, which can be visited by any individual on any day at any time.

Generally, the shrines that contain the actual tombs of religious figures enjoy a higher rank than others and are visited more frequently. Those shrines that have been built for persons not interred in them, such as the *Maqam al-Sharif* in the Mount Lebanon village of Sharun, which is dedicated to al-Muqtana Baha al-Din (d. 1043), are believed to have been the sites of miraculous events.

Hoping for a cure, those suffering from physical or mental afflictions, or sick at heart, may sit or sleep in the room beside the tomb. The room containing the tomb – and all shrines have tombs irrespective of whether or not the body of the *wali* is buried there – is always approached with respect and reverence. The visitor enters the shrine-room barefoot (women also cover their heads), kisses the tomb, offers a donation and, then, silently recites his or her prayer, ending it with an appeal, wish, pledge or vow. Inside the room, it is forbidden to speak loudly, shout, laugh, kiss, hug, smoke, eat, sing or dance. Sheikhs visit the shrine late in the evening to hold their own prayers, which may continue until the following morning. By contrast, the atmosphere in the courtyard is more relaxed. Here, people talk in low voices, smile, laugh softly,

eat, and sometimes, they are permitted to dance and sing, especially on the death anniversary of the person who is being commemorated. Indeed, some shrines are frequented mostly by women and children, who, in addition to performing the rituals, also go there to socialize. While the women cook in fulfilment of a vow, the children play in the courtyard. For young people and the uninitiated, the saint's day is seemingly a fair. The festival atmosphere has recently inspired the Druze religious authorities in Lebanon, Syria and Israel to build new facilities to accommodate the emerging style of assembly. It is now common in Druze shrines to have multiple halls – one designated a *khalwa*, the others, resting places – with kitchen facilities on the side.

In order to assure themselves of the success of their wishes, visitors to a shrine often take away pieces of coloured cloth that they use as votive tokens of divine blessings – often as amulets worn as necklaces or hung in houses or cars. Like other religious communities, the Druze use amulets prepared by their sheikhs for healing purposes or protection from danger.

The Druze not only make vows and visit shrines of individuals that fall exclusively within Druze history, but also share in the veneration of certain shrines that are held sacred by certain Christian and Muslim communities.

Druze Khalwas
Next to the shrines in spiritual value are the various *khalwa*s that the pious visit regularly for

worship. The word *khalwa* is used among the Druze in three senses: to refer to a physical structure such as a room, a hall, or a building; in reference to a person or group seeking solitude for purposes of worship; or to describe the rites performed in these spaces. As a specialized physical structure, a *khalwa* is not built in every Druze settlement. However, as a ritual form of worship, it is performed by all sheikhs advanced in the practice of religion.

As a ritual, a *khalwa* can be conducted at home, in a *majlis*, or in a separate retreat; it does not follow a fixed procedure and tends to vary with personal conviction. Some seek solitude for a day, others for a week or a year, and very few, for a lifetime. In their *khalwa*, the worshippers pass the time praying and continuously recalling the name of God. Some spend their time memorizing and then reciting the Qur'an by rote, while sheikhs may fast during the day and pass the night in a *khalwa* appealing for God's mercy.

Inside the *khalwa*, attendants light candles and speak in low voices. This is where the sheikhs of advanced standing meet for worship, practice religious rites and discuss details of the scriptures and significant current affairs affecting the Druze community at large. The first thing that novices learn in a *khalwa* is how to discipline their desires, look into and cleanse their souls and subsist on natural products.

The *khalwa*s have little furniture; some have no beds, no heating stoves and no refrigerators.

The floors of the *khalwa*s are covered with blankets and mats, with a few cushions scattered near the walls. If the *khalwa* is for one person, it is no larger than a small room with a kitchen and bathroom. Sometimes it is so small, you can sleep there, but you cannot live within its confines. During my visit to al-Bayyada in Lebanon, I was told that the local sheikhs had initially disapproved of running water and electricity at the retreat, choosing an ascetic life consuming food they produce with their own hands and serving visitors fruit from their own gardens.

Druze Majlises

Unlike *khalwa*s, which are used only by advanced sheikhs for worship, or to discuss the Druze scriptures and pressing matters facing the community, *majlis*es are open to the public, both to the initiated and uninitiated. Whereas a *majlis* can be used as a *khalwa*, a *khalwa* can never be used as a *majlis*. According to several Druze community members I spoke with, the present Druze *majlis* is a continuation of the Fatimid *majlis* and probably began between 1017 and 1041 while the Druze were still actively seeking new converts.

Like the *khalwa*, the *majlis* is a very austere place: no pictures of any kind, no decorations, chairs or sofas – only mats and blankets on the floor and cushions alongside the walls.

On Thursday evenings after the *maghrib* prayer, the most propitious of gatherings takes

Figure 32. Amir Shakib Arslan Mosque, Mukhtara, Lebanon

The largely Druze town of Mukhtara in Lebanon is home to this inventive form of mosque, commissioned by the leader of Lebanon's Druze community, Walid Jumblatt, in 2016. While the Druze community do not pray within a mosque, the aim of this project was to celebrate the diverse forms of mosque in order to encourage a pluralistic and tolerant approach to the various interpretations of Islam.

place at the *majlis*. On this occasion, both the *juhhal* and the *uqqal* attend. All members listen to a *wa'z,* or pious exhortation, often given by the *sayis* (leader, caretaker) of the *majlis*, or one of the other sheikhs. The *wa'z* usually contains stories and poetry of revered individuals amongst the Druze and exemplifies them as models of particular virtues. Extracts from biographies of the Druze *hudud* (ministers) as well as medieval Sufis are not uncommon.

When the entirety of the congregation is present, the *sayis* asks one of the sheikhs – often the most renowned among them – to read excerpts from a book called *'safin'* or *'safina'*. Amongst other things, these books contain aspects of classical Greek philosophy, excerpts from the life of the Prophet Muhammad and his companions, works by prominent Sufi writers, such as al-Hallaj (d. 922), al-Junaid (d. 910), and Rabi'a al-Adawiya, alongside a host of religious poems composed by various Druze sheikhs. The *safin* is not a standard text; every sheikh of some prominence has his own collection. The reading is then followed by the chanting of *shi'r ruhani* (spiritual poetry), praising the founders of the Druze tradition. Following this, the uninitiated leave the congregation and those who stay resume their prayers, chants and appeals.

Further reading, reciting and discussing excerpts from the Druze *Epistles* take place, in addition to reciting religious poetry. Meetings that include chanting or poetry recitation, which are often led by the high-ranking sheikhs, are

referred to as '*dhikr* circles' and also form part of the *khalwa* ritual, leading many members to liken it to Sufi modes of worship.

* * *

As a result of the varied historical trajectories of certain Muslim communities, a number were increasingly alienated from participation in the communal Friday prayer. In other cases, the mystical or interior understanding of Islam led some of these communities to focus on inward practice. As part of this interpretation, a series of alternative practices and modes of piety developed, associated with different spaces and institutions of worship from the *zikr-khana* of the Zikris to the *majlis* of the Druze.

These rituals and spaces facilitate the same orientation towards the Divine as the *salat* and *masjid*: they too mediate sacred text through charismatic figures, sacred knowledge and pilgrimage sites in expression of different modes of piety. Through each of these cases, we further expand our conceptions of what Islam is and how it comes to be interpreted in its myriad expressions.

Conclusion

The Power and Perils of Pluralism

Across almost all cultures that have embraced Islam, a plurality of sacred spaces has been more than just tolerated – it has been facilitated. However, the histories of the diverse Muslim spaces I visited on my journey have to a large extent been neglected or, at best, have fallen outside the broader narrative of Islam. Where these spaces have made an appearance, they have done so as local, independent institutions relegated to a particular community or geography, rather than being brought into conversation with other spaces of worship within Islam more widely. In some cases, they have even been thought of as divergent spaces belonging to marginalized groups.

Similarly, there has been a tendency to homogenize spaces of worship in the Muslim world. It is widely understood that although the seeds of the mosque were planted during the Prophet's lifetime, their widespread presence blossomed only later, as Muslim empires expanded. Herein lies the problematic assumption that the diffusion of Muslim institutions in different geographic and cultural milieus

mirrored one another, with the mosque being the dominant form.

The most revelatory element of my journey has been encountering the sheer range of spaces devoted to Muslim practice in its various forms. As we have seen, there are communities that have developed or inherited other spaces for the purpose of ritual activity, either in addition to the *masjid* or where a distinct space is used exclusively and not associated with the *masjid* at all. As Muslims of various schools of thought and interpretation have made their homes in new regions, they have created spaces adapted to the new environments. This has also happened when the environment of an existing terrain has changed due to a less hospitable political regime, a natural or human tragedy, or when it seems to have lost its connection with the community. Everywhere I visited, I was constantly encountering new permutations and nomenclatures of space – each of which has a story to tell. Those stories, as they continue to unfold, are narratives about space, architecture, culture and faith as well as the intersection of these elements which give a community its unique identity.

Yet, in recent years particularly, we have seen the negative impact of conflating spaces with faith and identity. We are increasingly witness to mosques, shrines, *khanaqah*s and *jamatkhana*s across the world being attacked because they are associated with minority communities whose beliefs are not well understood. Our collective heritage, treasures and traditions alike, are under

threat from the idea of uniformity and those that would impose it rather than accepting the natural unity of our world's diverse elements.

We should also be aware that while two spaces may share a name, that does not necessarily mean that they share the same purpose. Take, for example, the *husayniyya* of the Twelver Shi'i community in Tehran and the *husayniyya* of the Ni'matullahi, also situated in Iran's capital. In the same way that we can recognize two spaces as distinct because of their individual architectures, we should also be open to understanding that a similarly named structure may share relatively little with another – whether in its practices, its social norms, its rules, its function or administration. These differences are not to be feared but to be understood and welcomed as opportunities to see the world from another perspective, from outside ourselves. For a space is not only about its name and form but also about the community it houses and the notions of connection and belonging that it inspires – notions we can all relate to and which enrich us collectively.

Meanwhile, women's access remains contentious, with many spaces not admitting women at all, contrary to the Prophet's practice, or else providing wholly inadequate facilities for them. Other 'marginal' groups such as elderly and disabled people can also struggle to have their needs met. At a time of compartmentalization of groups of varied orientations, it would seem that spaces of worship have failed to escape the

wrath of reductionism. In light of this, it is ever important to recall the pluralistic expressions that have characterized spatial histories, and to pay attention to the grassroots developments that are starting to occur in terms of inclusivity. Through acknowledging the complexity of spaces of worship across the Muslim world, we are alerted to the richness of Islam as a vibrant and universal faith.

Even the most informal spaces can engender the strongest sense of affinity for a community. I found that to be the case especially during my times praying at the Hilalliya Zawiya in Aleppo. While modest in size, the intimacy created when we all chanted in unison as a single spiritual family was astonishing; the subsequent mood created through our devotions was accentuated by the ambience of the uncovered market street outside, giving rise to moments of peace that are not often felt in one's lifetime. It is in such moments that we are reminded of the nourishment that shared experiences of peacefulness and unity can provide. That there are so many diverse spaces where this nourishment can take place is surely something to celebrate.

Glossary

ahl al-bayt Lit. 'people of the house', meaning the Prophet Muhammad and members of his household, including his cousin and son–in–law Ali b. Abi Talib, his daughter Fatima, and his grandsons Hasan and Husayn, as well as their progeny.

ahl al-sunna wa'l-jama'a Lit. 'people of the tradition and the community'. A collective term for adherents of Sunni Islam; it was applied to those early Muslims who believed that succession to the Prophet resided in a series of deputy companions or caliphs.

alam A 'flag' or 'signpost'. *Alam*s are ornate religious standards seen in Shi'i spaces of worship and during Muharram processions. They are often made of steel and crowned with emblems detailing the names of the *ahl al-bayt*.

ashurkhana A Shi'i space used for collective mourning rituals and the safe-keeping of relics and *alam*s. The *ashurkhana* hosts annual Muharram rites and serves as a space where worshippers may come to seek blessings through the *alam*s.

baraka pl. *barakat*	Blessing(s). In Islamic belief, *baraka* comes from God and can be granted to people, places and objects.
caliph	Leader of the Muslim community. By the 10th century, the Arabic *khalifa* meant a successor to the Prophet Muhammad and denoted temporal authority.
dhikr	Devotional acts of remembrance that include the rhythmic invocation of God's name and attributes. This practice is most often associated with mystical communities in the Muslim world.
du'a	'Invocation' or 'supplication'. In the Ismaili context the *du'a* is a daily prayer which invokes God, the names of the Prophet and the Imams.
hadra	Lit. 'presence'. A collective *dhikr* gathering which can include rhythmic invocations and bodily movements.
husayniyya	Found in Iran, Lebanon and Iraq, the term *husayniyya* is most commonly attributed to structures which house annual Muharram commemorations and rituals of mourning for Shi'i communities.
imam	Generally used to denote a leader, whether a prayer-leader or caliph. In Shi'i Islam, it refers to the designated Imams from the *ahl al-bayt*.
imamate	The institution of authoritative political and religious leadership, which in Shi'i Islam refers to the designated

Imams from the Household of the Prophet.

imambara Lit. 'enclosure of the *imams*'. *Imambara*s are structures found in South Asia that are devoted to the events of Karbala and its martyrs, hosting rituals during Muharram and displaying religious relics.

Ismailis Adherents of a branch of Shi'i Islam following the line of Isma'il, the eldest son of the Shi'i Imam Ja'far al-Sadiq, from whom the Fatimid Imams claimed descent.

Ithna'ashari Lit. 'Twelvers', the majority branch of Shi'i Muslims, who acknowledge 12 Imams in lineal succession from Ali b. Abi Talib. After Imam Ja'far al-Sadiq, they acknowledged his younger son, Musa al-Kazim, as their Imam.

jami' A larger space of worship used to hold daily *salat* rituals and in particular Friday congregational prayers which are preceded by a *khutba*.

jamatkhana Lit. 'house of the community'. For Nizari Ismailis, the *jamatkhana* serves as the primary space of communal gathering and ritual practices, including the daily *du'a*.

khalwa A *khalwa* is a small room for meditation, reflection and reading of the Qur'an. For the Druze community, the term *khalwa* can either refer to a physical structure, a person or group seeking solitude for purposes of worship, or the rites performed in these spaces.

khanaqah	The term *khanaqah* refers to the space used by various Sufi communities. It can serve as a teaching centre for disciples, a lodge, a place of communal worship and the burial site of Sufi masters.
khutba	A sermon delivered in a mosque at Friday prayers.
madrasa	A place of study, traditionally attached to the mosque, where instruction involves Islamic theology.
majlis	Lit. 'a place of sitting', used to signify a religious assembly. For Shi'i communities this involves the gathering for the purpose of mourning and remembering the *ahl al-bayt*. For the Druze community a *majlis* refers to their primary communal and ritual space.
maqam	A shrine built on a sacred site or where the body of a saint or religious figure is interred.
matam	The term *matam* is used to collectively refer to the gestures of lamentation that Shi'i communities express during Muharram and Ashura. This may include chest-beating or self-flagellation.
masjid	Lit. 'a place of prostration' or 'mosque'. The *masjid* is primarily a designated space for the offering of canonical ritual prayers by Muslim congregations. Besides its religious function, the *masjid* can be the centre of community life which may serve social, political and educational roles.

mihrab	A niche in the wall of a mosque that signifies the direction of prayer.
minbar	A stepped platform in a mosque used by the imam to deliver the *khutba.*
muezzin	A person who recites the call to prayer at the prescribed times of day.
nass	Lit. 'text' or 'stipulation'. In Shi'i Islam, it refers to the Prophet Muhammad's declaration of Ali as his successor, and by extension, to the requirement that each Imam should explicitly appoint the following Imam. The concept of *nass* was developed in the early decades of Shi'i Islam, when several people claimed the imamate for themselves, especially in the times of Imams Muhammad al-Baqir and Ja'far al-Sadiq.
qibla	The direction of Muslim prayer towards the Ka'ba in Mecca.
qutb	Lit. 'pole' or 'axis'. In Sufi communities this title is often used to denote the spiritual leader of an order who is thought to mediate between the divine and the human and whose presence is deemed necessary for the existence of the world.
salat pl. *salawat*	A Qur'anic term referring to prayer in general, which later came to be used more specifically for the daily ritual prayer.
sama	Lit. 'listening'. A practice common to Sufi communities which involves the listening to music, chanting and

sometimes dancing as a means of shifting one's consciousness to become closer to God.

silsila Lit. 'chain.' A line of spiritual descent linking masters of a Sufi group to the founder of the order and eventually to the Prophet Muhammad.

tariqa Lit. 'a path'. In the Sufi tradition a *tariqa* indicates an order or school of interpretation that follows its own organization, practices and lineage of spiritual masters.

ta'ziya In Iran a *ta'ziya* refers to a passion play; a mourning ritual during Muharram that re-enacts the death of Husayn at the Battle of Karbala. In South Asia, a *ta'ziya* is a rendition of Husayn's shrine at Karbala, usually made of paper and bamboo, and carried during processions in Muharram. These are sometimes ritually immersed into water on the day of Ashura.

takiya A site in which annual Muharram commemorations are observed by Shi'i communities; its Persian variation '*takiyeh*' can be used synonymously with *husayniyya* in parts of Iran. A *takiya* can also refer to a Sufi dwelling place.

umma A community; people who are followers of a particular religion or prophet. It refers in particular to Muslims as a global religious community.

walaya Lit. 'authority' or 'guardianship'. A principal belief of Shi'i Islam, linked closely to imamate, denoting devotion and obedience to the *ahl al-bayt* and acknowledgement of the Imam's right to succeed the Prophet Muhammad.

wali
pl. *awliya* Lit. 'friend'. In particular, Friend of God. The term could also be used in reference to the Shi'i Imams and, in Sufi traditions, to saints.

zawiya A place of worship where Sufi communities congregate for weekly *dhikr* sessions. The term *zawiya* may also refer to a corner of a mosque where an aspirant would isolate himself reciting *dhikr*.

Further Reading

This work has benefited from a wide body of literature concerning spaces of worship in Islam, and Muslim communities and architecture more broadly. While the archetype of the mosque has often dominated this field of scholarship, this book has consulted a variety of works – both early and contemporary – to offer an inclusive account of Muslim piety in the 21st century. Below is a list of these works, arranged according to the broader fields of knowledge that they contribute to.

* * *

Islamic Architecture

Allan, James W. *The Art and Architecture of Twelver Shi'ism: Iraq, Iran and the Indian Sub-Continent.* London, 2011.

Allan, James W., and K. A. C. Creswell. *A Short Account of Early Muslim Architecture.* Cairo, 1989.

Behrens-Abouseif, Doris. *Islamic Architecture in Cairo: An Introduction.* Leiden, 2009.

Blair, Sheila, and Jonathan Bloom. *The Art and Architecture of Islam 1250–1800.* New Haven, 1994.

Frishman, Martin, and Hasan-Uddin Khan. *The Mosque: History, Architectural Development and Regional Diversity.* London, 2002.

Goodwin, Godfrey. *A History of Ottoman Architecture.* London, 1971.

Hillenbrand, Robert. *Islamic Architecture: Form, Function and Meaning.* Edinburgh, 1994.

Necipoğlu, Gülru. *The Age of Sinan: Architectural*

Culture in the Ottoman Empire, 1539–1588. London, 2005.

Saleem, Shahed. *The British Mosque: An Architectural and Social History.* London, 2018.

Uluhanli, Leyla. *Mosques: Splendors of Islam.* New York, 2017.

Muslim Communities

Aghaie, Kamran Scott. *The Martyrs of Karbala: Shi'i Symbols and Ritual in Modern Iran.* Seattle, 2004.

Daftary, Farhad. *The Isma'ilis: Their Histories and Doctrines.* 2nd ed., Cambridge, 2007.

Friedlander, Shems. *Rumi and the Whirling Dervishes.* New York, 1992.

Green, Nile. *Sufism: A Global History.* Chichester and Malden, 2012.

Haddad, Yvonne Yazbeck, and Jane I. Smith. *Muslim Communities in North America.* Albany, 1994.

Hazleton, Lesley. *After the Prophet: The Epic Story of the Shia-Sunni Split in Islam.* New York, 2009.

Khuri, Fuad I. *Being a Druze.* Beirut, 2004.

Netton, Ian Richard. *Sufi Ritual: The Parallel Universe.* New York, 2000.

Pinault, David. *The Shi'ites: Ritual and Popular Piety in a Muslim Community.* New York, 1992.

Suleman, Fahmida. *People of the Prophet's House: Artistic and Ritual Expressions of Shi'i Islam.* London, 2015.

Muslim Spaces of Worship

Fernandes, Leonor. *The Evolution of a Sufi Institution in Mamluk Egypt: The Khanqah.* Berlin, 1988.

Johns, Jeremy. "The 'House of the Prophet' and the Concept of the Mosque." In Raby, J. and Johns, J. eds. *Bayt al-Maqdis: Jerusalem and Early Islam*, pp. 59–112. Oxford, 1999.

Katz, Marion Holmes. *Women in the Mosque: A*

History of Legal Thought and Social Practice. New York, 2014.

Khan, Hasan-Udin, and Martin Frishman. *The Mosque: History, Architectural Development and Regional Diversity.* London, 2002.

Kuban, Doğan. *Muslim Religious Architecture: Part II – Development of Religious Architecture in Later Periods.* Leiden, 1985.

Lifchez, Raymond (ed.) *The Dervish Lodge: Architecture, Art and Sufism in Ottoman Turkey.* Los Angeles, 1992.

Nizami, K. A. "Some Aspects of Khanqah Life in Medieval India", *Studia Islamica* 8 (1957), pp. 51–69.

Omer, Spahic. "From Mosques to Khanqahs: The Origins and Rise of Sufi Institutions", *KEMANUSIAAN* 21, 1 (2014).

Quraeshi, Samina. *Sacred Spaces: A Journey with the Sufis of the Indus.* Massachusetts, 2009.

Illustrations

Care has been taken to trace the ownership of all copyright material used in this book. Any information to rectify references or credits is welcome for subsequent editions.

Acknowledgements

This book would not have been possible without the thousands of Muslims who opened their homes and hearts to me. Thank you for entrusting me with your convictions, your dreams, your faith and the intimate details of your lives. You believed that it was important, if not essential, for your visions of Islam to be captured and for your definitions of 'Muslim' to be heard, seen and experienced. To you, I am indebted and truly grateful. In so many ways, these are your stories. I am simply the storyteller.

The research and writing of this book would not have been possible without the generous financial and intellectual support of The Institute of Ismaili Studies (IIS) in London. Over the years, many IIS colleagues and students, of all persuasions and proclivities, engaged me in countless stimulating conversations on a range of near-infinite topics dealing with Islam and Muslims. I would like to particularly thank Aziz Esmail, the late Mohamed Arkoun, Farhad Daftary, Azim Nanji, Shainool Jiwa and Shiraz Kabani for their guidance and support over the years of research and development of this work, alongside my colleagues in the Department of Community Relations. On the editorial side, I wish to extend my thanks to Tara Woolnough, Raeesah Akhtar,

Lisa Morgan and Russell Harris at the IIS for their invaluable editorial acumen, in partnership with Sophie Rudland and the team at IB Tauris/ Bloomsbury.

The presentations I have been invited to give on topics of lived Muslim diversity – now cover more than 16 countries – at universities, schools, places of worship and interfaith spaces, have been immeasurable. They have allowed me to further dialogue with audiences of all back-grounds and cultures who have prodded, politely disagreed and asked important questions. These interactions have allowed me to refine and nuance my frameworks of analysis, and strengthen my arguments to ensure their resonance remains anchored in the lived realities of Muslim congreg-ations and communities.

It is hard to put into words my appreciation for the encouragement and support of my many friends and colleagues who had the utmost confidence that the long gestation period of the book would be worth the wait, given the depth and intimacy that the research has yielded.

This book would not have seen its ultimate fruition without the unwavering support and sacrifices of my wife, Yashina Jiwa. Thank you for your constant encouragement and patience during the writing and revision process. It is my hope that our daughter, Nureya, will also find inspiration in these pages and will champion, along with her generation, the values of plural-ism that this book espouses.

In the above pages, I have done my utmost to

respectfully and honestly present the visions of Islam shared with me and demonstrated by the numerous Muslims I have encountered on my journey of research and adventure. It is simultaneously a grave responsibility and profound honour to be filled with these experiences and stories – to be both their cup-bearer and dispenser. While the book could not encapsulate within its pages the stories of every encounter, community or region, I have tried to capture as many as possible and to embolden these narratives with frames that make them intelligible and meaningful for what I hope will be the book's wide and varied readership. Any mistakes or errors I have made in collecting or sharing these with others are solely my own.

Note on the Text

In the interest of readability, diacritics for transliterated words have been limited to the *ayn* (') and the *hamza* (') where they occur in the middle of a word, with the exception of the final *ayn* in *jami*'. All dates are Common Era, unless otherwise indicated. Again, unless otherwise specified, English quotations from the Qur'an are based on Yusuf Ali's translation. Supplementary material related to the content of the book is available on the IIS website: www.iis.ac.uk

Index

World of Islam Series

The *World of Islam* series aims to provide non-specialist readers with a reliable and balanced overview of the diverse manifestations of Islam. It seeks to redress misperceptions by offering a nuanced survey of the plurality of interpretations amongst Muslims around the world and throughout history, who express their faith and values through varied cultural, social, intellectual and religious means. Covering themes pertinent to Muslims and non-Muslims alike, the civilizational series approach encourages readers to delve into the commonalities as well as the distinctions that define different Muslim traditions. In accessible language and concise format, these books deliver well-researched yet easy-to-follow introductions that will stimulate readers to think differently about Islam.

Be inspired by the World of Islam.

The Institute of Ismaili Studies

The Institute of Ismaili Studies was established in 1977 with the object of promoting scholarship and learning on Islam, in the historical as well as contemporary contexts, and a better understanding of its relationship with other societies and faiths.

The Institute's programmes encourage a perspective which is not confined to the theological and religious heritage of Islam, but seeks to explore the relationship of religious ideas to broader dimensions of society and culture. The programmes thus encourage an interdisciplinary approach to the materials of Islamic history and thought. Particular attention is also given to issues of modernity that arise as Muslims seek to relate their heritage to the contemporary situation.

Within the Islamic tradition, the Institute's programmes promote research on those areas which have, to date, received relatively little attention from scholars. These include the intellectual and literary expressions of Shi'ism in general, and Ismailism in particular.

In the context of Islamic societies, the Institute's programmes are informed by the full range and diversity of cultures in which Islam is practised today, from the Middle East, South and Central Asia, and Africa to the industrialized societies of the West, thus taking into consideration the variety of contexts which shape the ideals, beliefs and practices of the faith.

These objectives are realized through concrete programmes and activities organized and implemented by various departments of the Institute. The Institute also collaborates periodically, on a programme-specific basis, with other institutions of learning in the United Kingdom and abroad.

In facilitating publications, the Institute's sole aim is to encourage original research and analysis of relevant issues. While every effort is made to ensure that the publications are of a high standard, there is naturally bound to be a diversity of views, ideas and interpretations. As such, the opinions expressed in these publications must be understood as belonging to their authors alone.